THE LIGHT CLUB

JOSIAH McELHENY

THE LIGHT CLUB

On Paul Scheerbart's *The Light Club of Batavia*

WITH CONTRIBUTIONS BY
Gregg Bordowitz, Ulrike Müller, Andrea Geyer,
and Branden W. Joseph

TRANSLATIONS BY
Wilhelm Werthern and Barbara Schroeder

ORIGINAL TEXTS IN GERMAN BY
Paul Scheerbart and Georg Hecht

THE UNIVERSITY OF CHICAGO PRESS | CHICAGO AND LONDON

The University of Chicago Press, Chicago 60637
The University of Chicago Press, Ltd., London
© 2010 by Josiah McElheny
All rights reserved. Published 2010
Printed in the United States of America

18 17 16 15 14 13 12 11 10 1 2 3 4 5

ISBN-13: 978-0-226-51457-4 (cloth)
ISBN-10: 0-226-51457-9 (cloth)

Library of Congress Cataloging-in-Publication Data
McElheny, Josiah, 1966–
 The light club : on Paul Scheerbart's the light club of Batavia / Josiah McElheny with
contributions by Gregg Bordowitz, Ulrike Müller, Andrea Geyer, and Branden W. Joseph ;
translations by Wilhelm Werthern and Barbara Schroeder ; original texts in German by Paul
Scheerbart and Georg Hecht.
 p. cm.
 ISBN-13: 978-0-226-51457-4 (cloth : alk. paper)
 ISBN-10: 0-226-51457-9 (cloth : alk. paper) 1. Scheerbart, Paul, 1863–1915. Lichtklub von
Batavia. I. Hecht, Georg, b. 1885. II. Scheerbart, Paul, 1863–1915. Lichtklub von Batavia. Eng-
lish & German. III. Title.
 PT2638.E4L536 2010

 833'.912—dc22

All images in this book and on the cover are film stills from Josiah McElheny and Jeff Preiss,
Light Club, 2008, 16mm film transferred to high-definition video with audio, 72 minutes,
voiceovers by Martin Beck, Andrea Geyer, Ulrike Müller, and Claudia Steinberg. © Josiah
McElheny and Jeff Preiss.

The paper used in this publication meets the minimum requirements of the American Na-
tional Standard for Information Sciences—Permanence of Paper for Printed Library Materi-
als, ANSI Z39.48-1992.

". . . we all suffer from light addiction.
It is the most modern of diseases."

—Mrs. Hortense

CONTENTS

A SMALL, SILENT UTOPIA

An Introduction by Josiah McElheny

As an artist interested in twentieth-century modernist aesthetics, I have often been struck by the social circumstances that informed its development. The "modern look" had its beginnings in the efforts of small groups of aesthetes in Western Europe. Many of their expositions and publications took the form of proposals for alternative ways of living, plans that in the name of progress aspired to define an entirely new world. After World War II, this aesthetic style proliferated wildly and, in architecture especially, came to dominate the urban landscape worldwide. But an earlier, little-known iteration of the modernist dialogue, one that merged universalist politics with populist spirituality, described a world that would have looked entirely different than the one we now observe. This book attempts to revisit this conversation and the alternative set of possible modernities it defined through an unusual work of fiction from nearly one hundred years ago.

Like many on the left, I have not given up hope that we can dramatically improve our society. But we have to cope with historical facts, namely, the violent legacy of large-scale attempts to enact utopian ideals that at its worst is the repeated story of totalitarianism and murder. In the history of visual culture there are many examples of artists and archi-

1

tects, usually men, who propose new, more "functional" aesthetic lifestyles. But these visions always seem to require the systematic erasure of what already exists. Many artists and writers in the past few decades, from those involved with the Situationist International to the design and art collective N55, from Jacques Derrida to Simon Critchely, have speculated on whether the idea of utopia can be returned to in another, less annihilating form. I too have wondered if there is a model for utopia that encompasses its own doubt, considers its own inevitable faults and failures, and sees the danger of imposing on all the plans of a subjective few.

For this we might return to the time before those famous heroes of the modernist story—Walter Gropius, Mies van der Rohe, Le Corbusier—began their quest to remake our life of buildings, objects, images, and information. There, in a backwater of architectural history typically dismissed as illogical, subjective, "expressionist," we find another character: Paul Scheerbart. In his writings—novels, short essays, poetry, and criticism—Scheerbart describes a new world of architecture and technology, not to mention a new vision of sexual relations. For him, the problem lies not with how to imagine a new world, but in how to achieve it. What absorbs him are the politics of how to get there. It is often hard to tell in his texts what he intends as humor, satire, or a call to arms, but he continually returns to the idea that cultural stagnation can be overcome, that renewal is possible. So it cannot be said that his view of culture has a conservative or fatalistic outlook. But at the same time, the ideals that his characters set out to achieve at the start of his stories are never realized in the way that they were intended. Scheerbart's lesson is that one must begin with the knowledge that our plans will be fulfilled in

ways that we never expected. He proposes that the best we can hope for is an ironic utopia.

Scheerbart published *Der Lichtklub von Batavia: Eine Damen-Novellette* (*The Light Club of Batavia: A Ladies' Novelette*) in 1912. It is a little-known text; the tale is rarely included in bibliographies of Scheerbart's collected works. Translated into English here for the first time, it tells about the formation of a club dedicated to building a spa for bathing, not in water, but in light, at the bottom of an abandoned mineshaft. Its themes of hope, desire, and madness are clear, even in this brief description. The narrative unfolds at a hotel in "Batavia," which in Scheerbart's time was the name for Jakarta, the capital of the Dutch colony in Indonesia, but in the late eighteenth century was also the name of the Netherlands itself. As was typical, the location remains ambiguous, though the mosquitoes and humidity are suggestive of his interest in "exotic" locales.

Der Lichtklub was published in the very first issue of *Die Kritische Tribune*, a journal of politics, literature, and cultural criticism that only survived for one year. Scheerbart's story, subtitled somewhat subversively *Eine Damen-Novellette* (*A Ladies' Novelette*), was in this context a kind of "diversion within the frame"—it appeared between an essay on the war in Tripoli involving the Ottoman Empire and Italy, and a piece on corruption in the Reichstag (the parliament in Berlin). Scheerbart's subtitle signals from the start his abiding desire to goad the self-satisfied status quo.

Scheerbart wrote *Der Lichtklub* as a *Novelle* (his use of the phrase *Ladies' Novellette* is more mischief), a literary genre popular in Germany. Not a short novel, and not a short story as it exists in literature in English either, the *Novelle* is marked by its focus on a single event or chain of events that lead to a

surprising, often ironic, turning point. The plot is described in a brief, schematic manner; subnarratives are suggestively sketched in the fewest possible words. Within this format, Scheerbart is surprisingly effective at conjuring another reality, but his deadpan language leaves one uncertain of his intentions. It was the elliptical, self-reflexive, and fanciful quality of *Der Lichtklub* that first suggested to me the possibility of a speculative expansion of this strange story. The explorations that unfold in this book are a collaborative attempt at doing just that: examining the resonant, romantic, ridiculous, repugnant, and sublime proposal Scheerbart envisions.

Scheerbart

Paul Scheerbart was born in 1863 in Danzig. His father and mother were both dead by the time he was ten; he moved to Berlin at the age of twenty. His father practiced carpentry among other professions; his mother was a deeply religious woman. Primarily self-educated, Scheerbart never graduated from gymnasium though he took the examinations more than once. He began writing for newspapers in Berlin in 1885, covering everything from politics to crime to cabaret. He himself paid for his first novel, *Das Paradies: Die Heimat der Kunst* (*Paradise: The Home of Art*), to be published in 1889, using a modest inheritance he received from relatives of his mother.

In addition to his novels about "astral romance" and other unusual subjects, he wrote regularly about fashion and the applied arts and in 1897 published his first essay focusing on glass in architecture. Later, in 1912, he attempted to found a society for glass architecture, which brought him in touch with the architect Bruno Taut. Soon after this, Taut was commissioned to create a pavilion for the Cologne Werkbund

Exhibition of 1914 (an exhibit of innovative building technologies and design) by the glass and construction industries. The two men became fast friends and in the end, Taut embedded various aphorisms and poetic phrases by Scheerbart about glass architecture in the interior walls of the pavilion, adjacent to a cascading fountain, such as "Colored glass / Destroys hatred" and "Light permeated the Universe / It comes to life in the crystal." Taut dedicated the building, the Glashaus, to Scheerbart.

That same year Scheerbart published two books, both about a utopian glass world. *Glasarchitektur* (*Glass Architecture*), a "novel" that is often mischaracterized as a kind of construction manual, comprises 111 aphorisms about the state and future of building with glass; in it he trumpets the eventual triumph and primacy of glass architecture throughout the world. The book, dedicated to Taut, formed a thematic template for *Gläserne Kette* (The Crystal Chain), a collaborative project that Taut began after WWI and Scheerbart's death, with a group of artists and architects. They shared drawings, manifestos, and poetry by mail, exploring the theme of a new world of brightly colored crystalline architecture. For the group (as it had been for Scheerbart) the crystal was a central motif and their correspondence touched on its rich metaphoric allusions. Perhaps the only building that expresses many of the Crystal Chain's ideals, albeit 40 years after the group's dissolution, is the Berliner Philharmonie by Hans Scharoun.

Scheerbart's *Das Graue Tuch und Zehn prozent Weiß: Eine Damenroman* (*The Gray Cloth and Ten Percent White: A Ladies' Novel*) from 1914 takes the form of a more conventionally structured narrative, and it echoes the inscrutable humor and misdirection of *Der Lichtklub*. It is the story of a "glass architect" and

his new wife, Clara, who travel the world building new colored edifices in a dirigible or "airship." At the beginning of the book, Clara signs perhaps the oddest prenuptial agreement ever proposed: she promises to wear only gray clothing with a maximum of ten percent white detailing, in order to not detract from the color schemes in her husband's creations. In a typical Scheerbartian move, the fascistic nature of her husband's demand is undermined and then left ambiguous: halfway through the story the contract falls apart but the marriage itself survives. It is unclear where Scheerbart stands on this; here again he creates a picture of progress toward a better world, an attempt that he proposes is both necessary and impossible.

Influence

Scheerbart knew many important figures in Berlin and was admired and influential in his own time. However, ten years after his death in 1915, few were interested in his work. Walter Gropius, who had for a time been a follower, and even Taut, had moved on to ideas they deemed more practical and consequential. By 1925 Taut was building socialist housing blocks for the middle class and Gropius was designing factory-like buildings for the Bauhaus. But influence can reappear or be rediscovered.

Until the 1990s, Scheerbart was a seldom-remembered figure, at least outside of Germany. In literary circles he is perhaps best known as a "science fiction" writer; in architectural history before the nineties, he is rarely mentioned though he plays an interesting role in two books on the letters and politics of the Crystal Chain. In fact, until the twenty-first century the only English translation of his major works was a 1972 publication of *Glass Architecture*. The contemporary reevaluation of modernist history has led many to reclaim him as a prophet of the Interna-

tional Style of modern architecture and as inspiration for recent developments in the use of glass in buildings. The former, at least, seems misguided, for Scheerbart did not believe that glass architecture represented the height of rationality, practicality, or functionality—tenets that Internationalist modernists hold dear. Far from it. He viewed glass architecture as instead offering the possibility for a new cosmopolitan spirituality and a transcendent connection to nature. Glass, for Scheerbart, embodied the metaphoric potentiality of color and light, and the crystal was the natural form that symbolized these ideals. In *Glass Architecture*, he dreamt of buildings that were antimonumental, always changing, never the same: "Then one thinks of the great palaces and cathedrals of glass and the villas of glass, of the town-like structures, on solid land and in the water—often in movement—and of ever more water in ever different colors. On Venus and Mars they will stare in wonder and no longer recognize the surface of the earth."

Translation, Frames, Critiques

The difficulties of translation, the difficulties inherent in the idea of utopia, and the difficulties of inhabiting the attitudes of the past in a meaningful way are all tackled in this book by creating a series of varying frames for Scheerbart's *Der Lichtklub*. The translations, responses, and commentary that follow attempt to address the problematic ideas, both evident and implied, within the story and perhaps more broadly in Scheerbart's oeuvre.

Der Lichtklub is from a time altogether different than our own. Though it speaks of a desire for a new, technologically improved world, a desire that seems vaguely familiar to us, it was written before the apocalyptic destruction of WWI and is infused with the prejudices and assumptions of the

premodernist era. The horror of that war and the resulting shifts in political and national identity separate us from his era. Scheerbart speaks in the language of a future that did not happen, so the implied politics in his story can be difficult for us to understand. *Der Lichtklub* combines optimism and friendly skepticism; its ambivalence—and its sexual politics— seems almost bizarre today.

The English translation of the story is by Wilhelm Werthen, a German, with some assistance from a period English-German dictionary I had in my studio. He worked to make the text as clear as possible to the contemporary reader, a task made difficult by the fact that the original is often confusing, even to native German speakers. Although Scheerbart's style is not complex, its brevity and contradictions make every word count.

A pair of Austrian and American collaborators have contributed a "poetic translation" of the text that addresses the gaps in our comprehension of Scheerbart's strange futuristic world by carefully considering issues of class and sexuality. In *From the Shadows*, artists and writers Ulrike Müller and Gregg Bordowitz rail against the blindness of Scheerbart's characters and reveal the constructions of their roles as women, as men, and especially as beneficiaries of wealth.

German-born, New York–based artist Andrea Geyer translates not only the language of *Der Lichtklub* but also the format itself. In *The Club of the Visionaries* she transforms the *Novelle* into a play and a critique of class and gender suggestive of Brecht's *Lehrstücke*, or "teaching-plays," a modernist, Marxist form he worked with in the 1920s and 1930s. Instead of critiquing Scheerbart's blind spots from a contemporary viewpoint, she plays Scheerbart's own game and creates yet another layer, satirizing further the societal roles played out in the original.

My own contribution is a portrait of a larger, ongoing project about *Der Lichtklub* that includes the translations and collaborations in this book, performances, film, and sculpture. I have tried to absorb Scheerbart's text and its critiques back into the traditional English literary form, the short story. *The Light Spa in the Mine* reflects the attitudes and methods that inform many of my artistic projects, such as my tendency to try to recolonize events from the past. It reframes *Der Lichtklub* as a history and creates a so-called metanarrative. The main character recounts an improbable tale about a forgotten moment in history by reciting passages of an obscure memoir that he has come to memorize through obsessive scholarly study. By bringing the text to our own era and fleshing out what Scheerbart appears to imply, I hope to highlight its parallels to our own moment, a time when technology is once again viewed as offering the best hope to satisfy longing and abolish shadows.

Commentary

For Georg Hecht, a poet who also died in 1915, Scheerbart was without peer. In his commentary (printed in the same issue of *Die Kritische Tribune,* and reprinted here with an English translation by Barbara Schroeder) he struggles to explain, without demystifying, this author he worshipped. For Hecht, it is the experience of reading *all* of Scheerbart's work that alone allows us to glimpse his meaning. It is as if Scheerbart can only be comprehended in a world that consists solely of his own prophesies.

Branden Joseph, an art historian and a founding editor of the journal *Grey Room,* inhabits Hecht's artlessness and style in an essay that responds to and expands on the poet's 1912 appraisal. Joseph unearths a new chain of influence when he describes

how Walter Benjamin, another visionary writer focused on the primacy of "experience," was deeply affected by Scheerbart. For Benjamin, Scheerbart was an example of what he called "the true politician," a phrase that points to the most important aspect of Scheerbart's thinking: his world of fantasy was in fact his attempt to discuss politics by other means.

Branden Joseph once suggested to me that *Der Lichtklub* provides a good outline of Scheerbart's oeuvre, in that it touches on his main themes of technology, architecture, and love, so perhaps this book could be used as a lens for examining some of his other numerous works and might encourage further translations.

Utopia Today, Tomorrow, Yesterday, or Never

Scheerbart was no revolutionary or anarchist. In fact, he saw himself as fighting against unthinking seriousness: "I became a humorist out of rage not out of kindness." Still, he wanted to participate in the construction of a new order, or at least an image of one. *Glass Architecture* is grounded not in the language of a new constitution but in descriptions and instructions for materials and methods of building. This tells us that Scheerbart viewed politics as something that had to be formed not of abstractions but out of everyday things.

It is striking that the protagonist of *Der Lichtklub*, the heiress Mrs. Hortense, whose longing for light begins the tale, is a missionary for the values that Scheerbart himself championed for so many years, but she, like all the others, does not get off easy. Each character is made to look the fool: they are oblivious, frivolous, insecure, or prone to conflicted motivations. At the beginning Mrs. Hortense declares the light spa should have "ten villas and two large hotels," space enough for many, and yet they

agree to construct it all in secret, to never divulge its location to anyone but themselves. They neglect to recruit followers to their scheme and at the end of the story are left with a brightly lit utopia that is silent and empty. None of Scheerbart's characters see the flaw in their plan. They believe that by confining the club to a population of five, their small utopia will remain forever unstained, uncorrupted, undimmed. But a world without a public is not really a world at all. These socialites forget that the most important aspect of any utopia is that there is at least the hope—or terror—of real people inhabiting it.

DER LICHTKLUB VON BATAVIA: EINE DAMEN-NOVELLETTE

von Paul Scheerbart

Die heiße Sonne ging unter.

Die Sterne gingen auf.

Die weiß gekleideten Kellner deckten die Tische für das Souper.

Die Lampions wurden angezündet – wie allabendlich – auf der Parkterasse.

Es war im Hotel de l'Europe, dem besten Hotel von ganz Batavia.

Unten im Park am kleinen Springbrunnen saß Mrs. Hortense Pline neben dem deutschen Architekten Mr. Hartung. Mrs. Hortense sagte:

„Wissen Sie, Mr. Hartung, hier ist am Tage zu viel Licht und in der Nacht zu wenig. Am Tage schläft man, macht Toilette, liest ein wenig und bereitet sich auf die Abendunterhaltung vor. Wenn nur mehr Licht in der Nacht da wäre. Mond und Sterne leuchten mir nicht hell genug. Sie sind ja herrlich – die Sterne – aber zu weit ab. Und ich leide an der Lichtsucht."

„Ich weiß wohl", versetzte der Architekt, der nur Glaspaläste baute, „warum Sie das sagen: Sie sind Ingenieuse, weiblicher Ingenieur. Und darum möchten Sie große elektrische Anlagen hier einführen. Aber die Nacht wird dadurch nicht viel heller. Und der Sternhimmel kommt dadurch nicht mehr zur vollen

Wirkung. Auf dem Erdboden zerstreut sich das Licht zu leicht. Das elektrische Licht erhellt wohl einen abgeschlossenen Raum – wenn er auch noch so groß ist. Im Freien aber ist alles künstliche Licht nicht expansiv genug."

„Was", sagte nun wieder Mrs. Hortense, „wollen Sie damit sagen? Das Wort Ingenieuse erinnert so heftig an Friseuse und Direkteuse. Das klingt so komisch. Aber das schadet nichts. Jawohl, Sie haben Recht. Aber sollen wir das in den schwülen Sälen anzünden?"

„Nein", unterbrach sie lebhaft der Architekt, „ich meine – ja – ich wollte eigentlich nur im Scherze reden. Es ist noch so schwül."

„Ihre Scherze will ich ganz ernst nehmen!" sagte da wieder Mrs. Hortense – und der Jupiter wurde dabei ganz hell und strahlend.

„Ja", fuhr nun der Architekt fort, „wenn Sie abgeschlossene Räume wollen, die nicht saalartig sein sollen, so kann ich Ihnen, gnädige Frau, nur empfehlen, ein Bergwerk zu erleuchten und da hineinzuziehen."

Mrs. Hortense sprang auf.

Und sie sagte hastig:

„Das ist ein erfrischender Einfall. Ich kenne ein Bergwerk, in dem Bergleute nicht mehr arbeiten. Es ist nicht zu warm und nicht zu groß. Wissen Sie was, Mr. Hartung? Wir wollen gleich jetzt beim Souper einen Lichtklub gründen. Oh! Ich habe ganz phantastische Pläne im Kopf."

„Jedenfalls", sagte der Architekt, „verspricht diese Gründung eine lebhafte Abendunterhaltung. Ich stehe als Architekt und Direktionsrat ganz und gar zu Ihrer Verfügung, wenn ich auch befürchte, daß dieser Klub bald zerplatzen wird wie eine Seifenblase."

„Bitte Mr. Hartung", sagte Mrs. Hortense mit zorniger Stirnfalte, „fürchten Sie nicht zu früh. Man kommt mit dem Fürchten immer noch zeitig genug. Die Herren fürchten sich immer. Das ist kein Zeichen von Mut. Wir Frauen sind weniger furchtsam. Deshalb bringen wir auch ganz allein die Weltgeschichte ein wenig vorwärts. Was würde aus der ganzen Welt, wenn der Mut der Frauen nicht da wäre?"

Da lachten sie beide, wie die Wissenden lachen, und gingen langsam zum Souper – auf die große Terasse, wo die Papierlampions angezündet waren. Die Diener schoben bereits die Gazewände zusammen – zum Schutze gegen die Moskitos. Beim Souper waren noch zwei reiche Amerikaner, die sich „Studien halber" in Batavia aufhielten – Mr. Benjamin und Mr. Krumhübel. Dazu kam noch eine Freundin der Mrs. Hortense – die Malerin Mrs. Arabelle Thackeray.

Mrs. Hortense sagte sehr bald, daß sie den Lichtklub von Batavia gründen möchte, bestellte zehn Flaschen Champagner und erhob sich, um mit einer Rede die Geschichte einzuleiten.

„Der Lichthunger", sagte sie lächelnd, „ist das markanteste Zeichen unserer Zeit – und nicht das übelste. Wir wissen, daß auf der Nachtseite des Sterns Venus an vielen Stellen ein heller Schein zu sehen ist. Man hat diesen Schein mit unsern Polarlichtern in Zusammenhang bringen wollen. Ich aber sehe darin, daß man auf der Venus weiter in der Lichtbereitung ist als auf dem Stern Erde. Man kann dort hunderttausendmal mehr und helleres Licht herstellen als bei uns. Nun – ich will mit der Venus nicht konkurrieren."

Mr. Hartung sagte:

„Bitte – keine Abschweifung!"

„Darum", fuhr die Dame fort, „will ich bescheidener sein. Ich

will hier nur ein nicht mehr im Gebrauch befindliches Bergwerk derart illuminieren, daß Ihnen allen die Augen übergehen sollen.

Wir wollen da Tag und Nacht Lichtfeste feiern. Wir leiden nach meiner Meinung alle an der Lichtsucht. Das ist die modernste Krankheit. Alle Fahrstühle im Bergwerk sollen elektrisches Licht haben – hinter buntem Tiffany-Glas. Ich setze voraus, daß Sie die Farbenwolken des Tiffany-Glases kennen. Die Villen des Bergwerkes und die Hotels sollen auch von oben bis unten aus Eisen mit Tiffany-Glas hergestellt werden – ebenso die Wagen der elektrischen Bahn. Auch große Licht-Säulen aus Tiffany-Glas sollen durch das ganze Bergwerk durchgehen – vertikal und horizontal und auch in Winkeln. An großen zehn Meter hohen Ampeln und Laternen in allen größeren Ecken des Bergwerkes soll kein Mangel sein. Das Architektonische arrangiert Mr. Hartung. Er baut, wie Sie wissen, nur Glaspaläste. Die sind in der Bergwerkstemperatur gut angebracht. Brand ausgeschlossen. Jetzt nur noch das Pekuniäre."

„Freilich", rief Mr. Benjamin, „ich gebe zehntausend Dollars."

„Ich", rief Mr. Krumhübel, „gebe zwanzigtausend Dollars."

Man schwieg. Mrs. Hortense ließ sich Madeira-Crême bringen, steckte sich eine Zigarette an und sprach:

„Ich akzeptiere die beiden Summen, erkläre aber, daß damit nicht viel getan ist. Die elektrischen Anlagen werden nicht billig sein. Doch – Wasserfälle sind in der Nähe meines Bergwerkes. Und ich sage, daß ich in Jahresfrist – wir schreiben heute den ersten Juli 1909 – mit dem ganzen Bergwerksetablissement fertig sein werde. Zehn Villen und zwei große Hotels sollen da sein. Wer's von Ihnen heute nicht glauben will, verspricht mir, wenn übers Jahr alles klappt, die

Erfüllung eines Wunsches. Ich setze dagegen – mein Schloß in Valparaíso.“

„Exotisch!“ rief Mr. Benjamin, „aber gnädige Frau, Sie dürfen nicht wünschen, daß ich Mr. Krumhübel oder einen anderen Ehrenmann heimlich Ihretwegen ermorde. Das tu ich nicht. Ich morde nie! Beim Barte des Propheten!“

„Ich“, bemerkte hierzu Mr. Krumhübel, „bin aber noch vorsichtiger. Der Wunsch darf auch nicht folgendermaßen lauten: ‚Lieber Mr. Krumhübel, gehen Sie hin und töten Sie sämtliche Löwen der Sahara!‘ – Das tu ich nicht.“

Die Stimmung wurde sehr heiter.

Mr. Krumhübel fuhr fort:

„Außerdem darf der Wunsch auch nicht gegen die guten Sitten verstoßen.“

Mr. Hartung sagte dazu:

„Ein Paragraph im Bürgerlichen Gesetzbuch des Deutschen Reiches erklärt jeden Kontrakt, der gegen die guten Sitten verstößt, für ungültig.“

Mr. Krumhübel replizierte:

„Leider gehört aber die gute Stadt Batavia noch nicht zum Deutschen Reich.“

Mrs. Hortense sagte:

„Jetzt wollen wir alles ganz ernst behandeln – und schriftlich. Mr. Hartung ist ja am Unternehmen beteiligt. Er hat wohl die Güte, gleich alles schriftlich aufzusetzen. Kein Mord! Auch kein Tiermord! Und nichts, was gegen die guten Sitten verstößt. Aber sie sollen merken, was die Energie der Damenwelt vermag.“

„Halt!“ rief da Mr. Benjamin, „ich erfülle auch Mrs. Arabelle Thackeray einen Wunsch, wenn das Gruben-Etablissement in der Tiefe – ganz hell – alle Düsterkeit verscheuchend – tatsächlich in Jahresfrist fertig wird. Ich glaubs nicht.“

„Wenn meine Freundin verliert", sagte Mrs. Thackeray, „verpflichte ich mich, ein Glas-Medaillon-Portrait von Mr. Benjamin für eine große Tiffany-Glas-Wand herzustellen – in doppelter Lebensgröße. Kopfstück! Mehr kann ich leider nicht gegensetzen."

Man gab sich alles schriftlich und debattierte danach über die Gründung bis zum Morgengrauen. Das dritte Wort war immer wieder: Glas! – Tiffany-Glas!

Am nächsten Abend dampften die beiden Damen mit dem Mr. Hartung ab – fuhren zu dem dunklen Bergwerk, das in Jahresfrist hell sein sollte.

––––––––

Und es ward hell.

Allerdings: Mrs. Hortense Pline hatte dabei ihr gesamtes garnicht unbeträchtliches Vermögen verpulvert.

Jedoch in Batavia kamen die Fünf im Juli 1910 wieder zusammen. Und Mr. Hartung bestätigte, daß alles hell sei. Mrs. Hortense wollte nun die beiden Herren bestimmen, gleich zu dem hellen Bergwerk, dessen Lage auf der Erdoberfläche ganz geheim gehalten werden sollte, mitzukommen. Doch die beiden Amerikaner wollten zuerst die Wünsche der beiden Damen kennen lernen.

Da sagte Mrs. Hortense seufzend:

„Ich verzichte."

Und Mrs. Arabelle Thackeray erklärte ebenfalls:

„Ich verzichte."

Nun fuhr man gleich zu dem illuminierten Bergwerk hin – und fand da alles in Wahrheit – lichtvoll im höchsten Maße – alles Licht hinter Tiffany-Glas.

Eine ganz – ganz – stille Lichtkolonie war's.

Selbstverständlich gabs gleich zwei neue Ehen – in dieser hellen Tiefe.

Die Farbenwolken des Tiffany-Glases leuchteten berauschend.

THE LIGHT CLUB OF BATAVIA: A LADIES' NOVELETTE

by Paul Scheerbart

Translated from the German by Wilhelm Werthern

The hot sun set.

The stars rose.

The waiters dressed in white were setting the tables for supper.

The lanterns were lit—like every evening—on the park terrace.

It was the Hotel de l'Europe, the best hotel in all Batavia.

Down in the park by the little fountain, Mrs. Hortense Pline sat next to the German architect Mr. Hartung. Mrs. Hortense said:

"You know, Mr. Hartung, there is too much light here during the daytime, and too little at night. During the day, one sleeps, makes one's toilet, reads a little, and prepares for the evening's entertainment. If there were only more light at night! The moon and stars do not shine brightly enough for my taste. They are splendid—the stars—but too far away. And I suffer from an addiction to light."

"I know very well," returned the architect, who built only palaces of glass, "why you say that: you are an engineeress, a female engineer. And therefore you would like to introduce large electrical installations here. But the night would

not get much brighter from that. And the starry sky would no longer have its full effect. On the ground light disperses too easily. Electrical light will illuminate an enclosed space, regardless how large. But in the open air, no artificial light can ever be expansive enough."

Mrs. Hortense said, "What do you mean by that? The word engineeress is so keenly reminiscent of coiffeuress or directress. It sounds so odd. But never mind. Indeed, you are right. But are we obliged to only light these stifling halls?"

"No," the architect interrupted her in a lively fashion, "I mean—yes—I actually just wanted to speak in jest. It is still so hot and humid."

"I would like to take your jest quite seriously!" Mrs. Hortense said—and just as she said this, Jupiter became glittering and bright.

"Well," the architect went on, "if you want enclosed spaces other than great halls, then, dearest lady, I can only recommend that you illuminate a mine and move in there."

Mrs. Hortense jumped up.

And quickly she said:

"That is a refreshing idea. I know a mine where the miners don't work anymore. It is not too warm and not too large. You know what, Mr. Hartung? Right now during supper we will found a light club. Oh! I have the most fantastical plans in my head."

"At any rate," said the architect, "this plan promises lively evening entertainment. I am completely at your disposal as architect, and Director's Councilor too, even though I fear that this plan will soon burst like a soap bubble."

"Please, Mr. Hartung," said Mrs. Hortense with an angry

frown, "don't be afraid too soon. It is always early enough for fear later. Gentlemen are always fearful. That is not a sign of courage. We women are less fearful. That is why world history will be moved forward a little by us alone. What would become of the world if the courage of women did not exist?"

They both laughed then, knowingly, and slowly went to supper—to the large terrace where the paper lanterns had been lit. The servants were already pushing the gauze screens together—as protection against the mosquitoes. Also at supper were two Americans who were in Batavia to pursue their studies—Mr. Benjamin and Mr. Krumhübel. In addition, there was a friend of Mrs. Hortense's—the paintress Mrs. Arabelle Thackeray.

Very soon Mrs. Hortense announced that she wanted to establish the Light Club of Batavia, ordered ten bottles of champagne, and rose to inaugurate the affair with a speech.

"The hunger for light," she said, smiling, "is the most outstanding sign of our time—and not the worst. We know that on the night side of the star Venus, in many places a bright glow is visible. There have been attempts to link this glow to our northern lights, but to me this is evidence that on Venus they are ahead of us on our star Earth as far as the production of light is concerned. There, one can produce a hundred thousand times more, and brighter, light than here. Well—I don't want to compete with Venus."

Mr. Hartung said:

"Please—no digression!"

"Therefore," the lady continued, "I want to be more mod-

est. I only desire to illuminate a mine that is no longer in use, in such a manner that it will leave all of you flabbergasted.

We will celebrate light parties there day and night. In my opinion, we all suffer from light addiction. It is the most modern of diseases. All elevators in the mine are to have electrical light—behind colored Tiffany-glass. I assume you know the color-clouds of Tiffany-glass. The villas of the mine and the hotels are also to be constructed from top to bottom with Tiffany-glass and iron—and the same for the wagons of the electrical train. There will also be large pillars of light made from Tiffany-glass running through the entire mine— vertically, horizontally, and also at angles. There is to be no lack of grand ten-meter-high hanging lamps and lanterns in all the main corners of the mine. Architectural matters will be arranged by Mr. Hartung. As you know, he builds only glass palaces. They are appropriate for temperatures in a mine. Fire is impossible. Now to pecuniary matters."

"Of course," cried Mr. Benjamin. "I will give ten thousand dollars."

"I," Mr. Krumhübel cried, "will give twenty thousand dollars."

There was silence. Mrs. Hortense had Madeira Crême brought to her, lit a cigarette, and spoke:

"I accept the two sums, but I do declare that not much can be achieved with them. The electrical installation will not be cheap. Although—there are waterfalls near my mine. And I say that within the passage of one year—today we record as July the first, 1909—the entire mine establishment will be complete. Ten villas and two large hotels are planned. Whoever chooses not to believe me, today must pledge to

fulfill a wish of mine if everything works out within the year. I bet this against my Schloss in Valparaíso."

"Exotic!" cried Mr. Benjamin, "But my dear lady, you must not ask that I should secretly murder Mr. Krumhübel or any other man of honor. I will not do that. I never murder! By the Beard of the Prophet!"

"I," remarked Mr. Krumhübel, "am however even more careful. The wish must also not be: 'Dear Mr. Krumhübel, please go and kill all the lions in the Sahara!'—I will not do that!"

The mood became very gay.

Mr. Krumhübel continued:

"Also, the wish must not go against good morals."

Upon this, Mr. Hartung said:

"One section of the German Civil Code declares all contracts in breach of good morals as invalid."

Mr. Krumhübel replied:

"Unfortunately, however, the good city of Batavia does not yet belong to the German Empire."

Mrs. Hortense said,

"Now we want to treat everything with great seriousness—and in writing. Mr. Hartung has a stake in this enterprise. He will be good enough to set everything down in writing. No murder! No animal murder either! And nothing that is a breach of morality. You will see what the energy of the ladies' world can achieve."

"Stop!" cried Mr. Benjamin at this point, "I will also fulfill a wish for Mrs. Arabelle Thackeray, if the mining-establishment in the depths—completely bright—dispelling all darkness—is really finished within the year. I don't believe it will be."

"If my friend should lose," said Mrs. Thackeray, "I pledge to produce a glass medallion portrait of Mr. Benjamin for a large Tiffany-glass wall—double life-size. A bust! Unfortunately I cannot offer more."

Everything was set down between them in writing, and the debate about the club's establishment continued until dawn. Every third word was again and again: Glass!—Tiffany-glass!

The next evening the two ladies set off with Mr. Hartung—driving to the dark mine that was supposed to be bright within a year's time.

————

And it became bright.

However: Mrs. Hortense Pline squandered her not inconsiderable fortune to achieve this.

The five gathered again in Batavia in July 1910. And Mr. Hartung confirmed that everything was bright. Mrs. Hortense wanted to order the two gentlemen to accompany her immediately to the bright mine whose location on the earth's surface was to stay a complete secret. But first, the two Americans desired to be acquainted with the wishes of the two ladies.

Then Mrs. Hortense said, sighing:

"I decline."

And Mrs. Arabelle Thackeray also declared:

"I decline."

Then they immediately drove to the illuminated mine—and found everything to be true—full of light in the highest degree—all the light behind Tiffany-glass.

A very—very—quiet light colony it was.

Naturally there were immediately two new marriages—in those bright depths.

The color-clouds of the Tiffany-glass glowed intoxicatingly.

FROM THE SHADOWS

A Poem by Gregg Bordowitz and Ulrike Müller

Before the pitch.

Beginnings emerge from base materials. And so our story too
must arise from raw states of passion.

The origin of modern luminescence came into view from the
meeting of Aggression and Creativity. This happened before
our time. Before our story. It is a dimly lit fact.

Aggression and Creativity begot a daughter named Envy. She,
in turn, approached Money, the bastard child of Want and
Necessity with an altogether outrageous proposal.

These origins are barely remembered.

Nothing here is novel (it's just a ladies' novelette).
This text is an amusement!
This is how a male writer imagines women's pleasure!
Let there be light conversation and club sandwiches and
 champagne.
No less than ten bottles for half as many people.

In a park by a fountain. It's a late summer evening. Let's stand in the shadows, where biology is not a concern. Anyone can be anything. There seem to be two figures. It's dusk, and the dim light gives license. One wears a dress and the other a suit.

How is biology not an issue?
All cats are grey in the dark.
Do you feel like starting?
I think we're in the middle of it already.

She's a giggly female, but rich, and serious about it. She wants attention, entertainment, and a place in history under the scrutiny of intense illumination. She wants to see only who she wants to see and be seen by who she wants to be seen by. She says, If only all the light in the world would concentrate on this spot.

A performer asking for a spotlight.
All else falls away.
All else no longer exists!
A place both inside and outside.

Things we know:
1. Lichtsucht is the most modern of ailments.
2. The castle in Valparaíso is of no more interest.
3. Money is worth nothing, for it has all been spent (what once was a sizeable fortune).
4. I think she still has some of her neckties, and she still likes to wear them to this day.
5. All utopias require loss.

6. Things that once were essential are now forgotten.
7. The rich are driven to sacrifice their wealth for absurd folly, they prefer that to feeding the poor.
8. The miners are gone, their work is no longer necessary. Their sweat and blood has been transformed into the wealth fuelling our story.
9. Exploitation happens throughout history, but now we're talking about a time when science promised to liberate humans from nature.

He's an architect and a skeptic. He tells her that light cannot be captured and concentrated, that the world is round, and space being endless would swallow it all. Electricity is not powerful enough to defy the universe . . . she needs a man-made container for the bright world of her fancy. A defunct mine! That could work.

Bei Zeus! Jupiter turned all bright and brilliant.

And people believed that!
People believed.
A story for women.
A time for make-believe.

Now what? Are they flirting or talking business? She is brilliant and no one knows it yet. She seems desperate for attention, and she's a bit bored. She's in a spa. She's been napping all day, and reading ladies' magazines, and getting dressed and done up for dinner.

Nothing ever happens.

Let's move leisurely.
There's an etiquette.
Time for dinner.
It's dark now.

Can we start again? This time perhaps in the café of the Grand Hotel?

She's approaching with the architect when she sees another lady across the room. She tries, but fails to get the woman's attention. The object of her gaze is a craftsperson, a glass blower. There's something different about her. Yes. Artists can come from the lower classes. Their skills are enough to admit them to the illustrious circle. But let's not talk about class, just whisper to one another that we think she's not independently wealthy.

Flashes of brilliance occur in the space of a pause.
Ideas burn bright where the mind can luxuriate.
Supper at the Hotel de l'Europe.

On the terrace between inside and outside. The characters are enclosed within a mesh wire to let through the breeze, but not the beasts. Waiters dressed in white are lighting lights. The light spills out into the park. The moon, once the sovereign force over romantic encounters, is now deadly pale. Her dress is bone white, and lacey, and frilly. The men in evening suits, of course (are those tuxedos?). It's a black and white world.

It's cinema!
They're in a movie yet to be made.
It's a romance!
They're in a love story yet to start.

The entire place is illuminated by electric bulbs shaped like candles (perhaps they even flicker in timed intervals). It is that time in history when the new is only welcome in the guise of the familiar.

Our lady friend wants to get down to business. She gives a speech to propose the formation of a light club. A club for the concentration of light. She's not interested in romance and gossip, she wants something unique and lasting. And she's calculated the costs.

Isn't it a charming bet? The rich Americans will chip in.
The architect worries that the club will burst soon "wie eine
 Seifenblase."
Like a soap bubble, but he has nothing to fear.
Because the woman is a visionary.

The dreamer seduces the architect all the while staring at the glass artist who wears a monocle to catch the light. It sends flashes around the room. Yes, they're friends. Perhaps best friends.

A glass maker holds a fragile past filled with promise.
In the future, every surface will permit light to pass through it.

In between the dreamer and the glass maker, sits the architect. He is the beacon of German masculinity. He builds only crystal palaces. He's full of himself, and he's flirting with her. Speaking loud enough for all to hear, she is addressing all her passions in the direction of one listener. The architect thinks she's talking to him. He's humoring her . . . playing along. He is the rationality of science led astray by summer perfumes and the splendid woman next to him. The dreamer is pure inspiration, and she has lust for the monocled glass maker.

It's a triangle.
Everyone is in it for a reason.
The roles are not yet clear.
Or are they?

Tonight, the crystal palaces built by the architect stand far away, in the center of dirty, bustling big cities. His glass constructions have clear arching lines, they are airy but sturdy, and they are gigantic. They are held up by steel skeletons, but that's visible only for the cognoscenti. He figured it all out. His buildings are so transparent that the birds can't see them and break their necks in mid flight. Black silhouette eagle-shapes are painted on the big glass panes to warn the birds. That's how transparent the walls of his buildings are.

The architect may build houses, but the glass maker handles the molten stuff.

He builds palaces.
But she knows the material!
He calculates the height.
But she owns the rainbow!

She colors the world with a Tiffany lamp while the architect
zooms in and out . . . micro/macro kind of stuff. He is Euclid
to her Mandelbrot.

(This is a good moment for a toast, don't you think Liebling?)

O! to live in a Tiffany world! no more morbid church stories
 cast in stained glass!
O! to be inside a glorious history instead of peering through
 it –
O! to become light itself –
 To make a center of the world and inhabit it.

Tell me about the female world.
We have been talking about it all night, didn't you realize?

Fools say it's womblike, but what do they remember? It's
not comfortable at all, claustrophobic, don't you think? It's
a space of uncontrolled spills. It's messy, and bloody, and
smelly too.

"Ich kenne ein Bergwerk, in dem die Bergleute nicht mehr
arbeiten."

She says she owns a coal mine exploited long ago, abandoned
by capitalism, available, not too hot, and not too big. With
waterfalls nearby to generate electricity. Hers is a cool, a
brilliant plan.

In her vision, it's the space described by a crystal chandelier.
She decides that the future will be like living in a chandelier.
Where pain is bright and colorful
 and passions come in gold and green and pink.

Reflective surfaces are cruel. And bright white light hurts.

This is a horrifying text
 a nightmare declaring war against shadows
This is proto-fascism
 stirring a class struggle against all doubts and
 unknowables
 a utopia built on the work of deceased miners

Wait. The word fascism startled me out of my champagne
haze for a moment.

It just occurred to me that I am scared by these characters:
They're into a deadly kind of identity politics!
They're rich and drunk, aristocrats, industrialists, and
 dilettantes
 Yes! They look like figures in an Otto Dix painting
 now!
They hope to extinguish everything that doesn't reflect them
They're bored and rich and Germany has not yet grown big
 enough for them
They're into building mirror palaces
They are control freaks, women and men alike, German and
 American ...
Of course the Americans are there!

See their ugly faces twisting in the fine crystal?
Frick and Rockefeller
Ford and Edison

Two rich Americans on a study trip in Europe on the eve of
 war.
What's there to study?
What are we doing here?
And who are we in this story?

We are the dreamer
Or
We're the waiters.
We're the servants.

Don't servants dream too?
We have a choice—to embrace or reject the role of protagonist
 in a future state.
How can we reject our role—what if we want to eat?
Kill the host.
Would you?
Violence is in the air.
There is a meeting of the staff in the basement after all guests
 are gone.
Violence is a necessary tactic . . .
 I am a coward but I might still attend out of curiosity.
. . . the messy reality no one wants to discuss
Listen! It's all around us,
I overheard the dinner chat about new realities.

The rich form exclusive clubs.

The assembled members of the new light club made a bet to
create a new world within a year. They made solemn vows
and moral pledges to enlightenment ideals (in writing, signed
by all). They promised to do anything and everything that
they can, except they drew the limit at murder. They won't
even kill animals in the Sahara.

Why would murder occur to them?
What must they disavow?
Do they know deep down that their aesthetic ideals require
 violence,
 though they themselves will never have to pull the
 trigger?

Nichts das gegen die guten Sitten verstößt.
Oh no, I would never do any such thing.
Never ever.

The rich talk about building palaces on top of the corpses of
 dead miners
They'll grind our bones to make their new optics
They'll drain the oil from our flesh to grease the wheels of
 their new industries
They'll let only a few survive to work behind the scenes
 where the floodlights shine
 and cables as thick as arms and legs run hidden
 behind colored glass walls
They'll drain the world of champagne and take our dreams
 with them

They'll replace us with machines
Machines don't make demands
 they don't eat or shit
 and most importantly they don't cast human shadows

The courage of women is needed here.
Gender is the primary axis around which the new world turns.
Was würde aus der ganzen Welt, wenn der Mut der Frauen
 nicht da wäre!

How do we confront the fact that they want liberation for
 women
 they want sexual freedom
 and yet they want to build their world on the backs of
 the working class?
We are returned to a fundamental conundrum about the
 inconsistency of utopian aspiration
And we are not innocent
We also want liberation for women
We, too, embrace our desires
Yes, and we don't think much about the working class
 and we don't like them
Except in our porn
Ah yes, here comes the plumber with his ass sticking out

Where are the toilets in the palace of light?
The trouble is that we set our utopias in iron and hard crystal
while our dream images are fleeting and temporary

There were others at that time with a different aesthetic
In a house that lets in just enough light to dimly illuminate
 the core
They eat their food with tarnished utensils
They enjoy the scent of earth
They accept that sanity does not exist
Their aesthetic appreciates traces of decay
They know that light is best comprehended by peering into
 shadows

They wonder if:
All glimmers of light are embers cast off from the original
 cataclysm
 To gather the light is a questionable imperative
 Our universe emerged from an explosion
Are we merely agents conscripted to collect wayward sparks?

Why are we still so afraid?

Is there no light inside the womb?

At the end of the story
 women had the idea
 the Americans paid
 the dreamer married the glass artist
 and the artist married her back (two weddings)
 the Americans looked on in wonder

Then the light colony fell silent.

No radio? No cell phone reception either

The color clouds of the Tiffany glass shed their intoxicating
 light

Until one day someone tripped over the cord

Or the line got cut . . . by the restaurant workers

And the moon returned to rule.

THE CLUB OF THE VISIONARIES

A Play by Andrea Geyer

A day in July just before 7 o'clock. 1909.

Daylight went, night sky rose.

A soup kitchen. Inside a woman cleaning tables to prepare for supper. Candles are lit. A place known to be the best of its kind in town.

Outside on the ledge of a water trough sit two women. A WORKER *and a* POLITICIAN. *Twilight.*

DAISY, THE WORKER (*turns and speaks*): You know, during the day, there is too much light and at night there is too little. During the day you work, you talk, but all you really do is get ready for the night. If only there would be more light in the night. The stars and the moon are not bright enough. I find them beautiful and all—those stars—but too far out. And I need more than that pure longing . . . I am suffering an obsession for the light's shining glow.

POLITICIAN (*someone known to build only glass houses*): I know, I know, those illuminations of the day are addictive and worth longing for. I understand your desire and where

you come from: You are an Ingenieuse[1], a female engineer, a woman of a different kind. What you suggest is to introduce a great electrical power plant, lighting up the darkness of your nights. But your nights won't be much lighter employing that kind of power, and you will instead lose the romance of the deep black sky. The light you desire is far too fleeting in this world. Inside it might be able to retain its power to illuminate, no matter how expansive such an interior, but outside, in the world, mechanical intervention cannot produce enlightenment.

DAISY (*as if naïve*): What are you trying to say? You call me an Ingenieuse? Like Coiffeuse or Directeuse? What strange affiliations. But whatever you say, you are right. If I may follow your suggestions, what exactly do you think we should light then, inside such sultry salons?

POLITICIAN: Oh no, no, I mean—I just spoke jokingly. It is not sultry at all . . .

DAISY (*lifts an eyebrow*): Well, I decided to read your joke as if it were serious.

The stars above them seem to sprinkle more light than before. Mostly Jupiter in sight.

POLITICIAN (*wringing her hands, nodding her head*): Well, yes, then if you like. Let me see, an interior that is not vast but comfortable—then I should suggest, my dear Fräulein, the cellars. (*She pauses.*) The basements that lie underneath our city.

DAISY *jumps to her feet.*

DAISY: What a refreshing suggestion. (*She starts pacing back and forth as if in thought for a moment and then speaks hastily.*) I know a way of entry into a basement, one that extends into other buildings. With no food to store and so much poverty these days, there is no use of these cellars anymore. And they are not too warm and not too large. You know what? Right now, tonight at supper we should proclaim the formation of a club. It shall be called: The Club of the Visionaries. (*She stops and her face brightens.*) Oh, I have such fantastic plans in mind!

POLITICIAN: Oh well, at least this plan promises interesting entertainment for tonight. But if it can sustain itself, I will of course be available for the organization and the direction and the political representation of such endeavor.

The POLITICIAN *stands up and bows, leaning forward to kiss* DAISY's *hand, and then she continues with a smile*: Even though I anticipate that such a club would burst like a bubble right after its conception.

DAISY (*withdraws her hand*): Excuse me, my friend. Don't you worry about that right now. Worry comes soon enough. Politicians always worry. No sign of courage. We worry less. That's why we move the world. What would the world do without the courage of women like me?

Facing each other, they both laugh, knowingly. They straighten their slacks and proceed to walk hand in hand into the soup

kitchen. As they enter, another worker closes the window to lock out pests.

Two Americans have sat down already. They are in town on business. Also present is a friend of DAISY*'s, a poet named* BELLA. DAISY, *restless, soon feels the urge to announce "The Club of the Visionaries." She asks for some more red wine, which she shares with the others. Then she lifts her glass. History is about to begin.*

DAISY (*smiling*): The hunger, my ladies, the hunger for light, is the most significant sign of our times—and not a bad one. We know about the other side of Venus. About the light that glows from that side. It is a glow, that time and again so wrongly is compared to the dancing colored lights seen near the Earth's opposing poles. But what I see are the visionary qualities of Venus. It is ahead of the planet Earth and brightens all sides of life. Illumination is manifold and brilliant on Venus. I am not pretending that I want to compete with that but—

POLITICIAN (*interrupts impatiently*): Daisy, don't take us on a ride.

DAISY: I would like to start modestly for now. I would simply like to bring some kind of illumination to a few of the cellars and basements underneath our city. Unused in these dire times, I want to light them up, so that your eyes will gape in wonder. And I want to put these lights behind thin glass made of the colors of the sky and the air and the water. And these clouds of color will fall like rainbows—given you know what that means. Columns of light, vertical, horizontal, reach-

54

ing all niches and corners. Even the entryways, the staircases, the sleeping quarters should be flooded with colorful light flowing within columns of glass, high up and down low. There should be no deficiency in transparency and light. The politician will organize and engineer it all. Politicians know how to build glass houses, as we all know. I find the temperatures of cellars suitable. No fire possible. But now the practical . . .

AMERICAN (*shouting*): Of course I will put up 100 dollars.

THE OTHER AMERICAN (*jumping up*): I, I will put up 200 dollars.

DAISY *sits down and remains silent. She lights a cigarette.*

DAISY: I accept the money but will say that it won't pay for much. It won't only be a matter of money, but a much more difficult endeavor. There are waterfalls close to those basements. It is now July 1909, and I say, within one year, we will have it completed. Ten large rooms and two small ones should be done. Whoever does not want to believe in me now will promise to grant me a wish, if all works out. I bet my winter coat against it.

AMERICAN: Exotic! But my dear woman, you should not wish that I secretly murder the other American or any other woman in your honor. I never kill. By the apron of my mother!

THE OTHER AMERICAN: I am even more careful. The request cannot be of such kind that I am asked to go and kill all the lions in the desert. That I won't do.

The mood lightens again.

THE OTHER AMERICAN: And the wish should not entertain bad morals either.

POLITICIAN (*seriously*): A paragraph in the people's law of the German Empire states that all contracts that inscribe bad morals are invalid.

THE OTHER AMERICAN: Sadly we are not part of the German Empire.

DAISY: Let's be serious. Let's get a pen and paper. The politician is part of the deal and will set up the papers. No murder, no murder of animals. And no evil moralities. You should feel the power we have! How queer!

AMERICAN: Stop! I will also fulfill a wish for Bella, if the lightened establishment in the basement, that will scare away all darkness, indeed gets completed within one year.

BELLA: Well, if my girlfriend loses, I will make a portrait of the American, double her life size, out of glass and colors. More I cannot offer.

Everything was written down, and the women talked until the early morning hours. Every third word was glass—colorful glass, transparency, light, or vision.

The next night, the women and the politician rushed over to the cellar, which was to be illuminated within one year.

————

And then it became bright.

DAISY *had lost everything, her job, her house, her family. But in Batavia all five met again in 1910, at the same soup kitchen*

and the POLITICIAN *confirmed that there was light and the visions could begin.* DAISY *asked the two* AMERICANS *to come with her, right then, to follow her to the entrance of the illuminated basements that were kept secret from the outside world. But the two* AMERICANS *first wanted to grant* DAISY *and* BELLA *their well-deserved wishes.*

DAISY (*sighs*): I don't need anything.

BELLA (*also sighs*): I don't need anything either.

And then they went down into the cellar full of colorful light and found it true. Illumination everywhere, behind colored glass. A very, very quiet colony of enlightenment it had become.

—————

Of course there were two new unions born from the depth of the glowing cellars. The clouds of colors flowing through the glass were wild and beautiful.

———————————————————————

[1] In the German language, names for professionals are always gendered. The male gender is most often indicated with the ending "er" whereas the female gender ends in "euse." The word "Ingenieuse" is an invention by Scheerbart, a then nonexistent female form of the word Ingenieur (Engineer).

THE LIGHT SPA IN THE MINE

A Short Story by Josiah McElheny

"The Light Club of Batavia—that's what they called it, this little group of socialites and artists . . ."

He paused. He was imagining himself, indulgently, as Marlow in one of Conrad's novels—relating a little history to a lazy, captive audience. It was late afternoon and natural light seeped through the windows of the bar.

"The whole business was improbable," he went on after a sip of whiskey, "but remember that this was just before World War I, the beginning of the twentieth century. The idea of a new future was everywhere. Electricity was still relatively novel—people thought it was transforming life itself. New ways to generate it were popping up all over the place, and everyone had heard of Tesla's dream of transmitting it without wires."

He caught his breath. Was he getting ahead of himself? Maybe it was worse; this could be a second or third performance for some of the regulars. Here he was again, reciting bits of his tome on twentieth-century futuristic schemes. What made him think that something that had failed to convince his tutor a decade ago would go over any better now? Idly repeating memorized speeches, in altogether the wrong place, perhaps he hoped that his obsessions would mutate into a better truth.

"It was a summer evening in 1909, just as the sun set. Stars

were suddenly appearing. They had opted to dine outdoors in the garden of the Hotel de l'Europe—considered at the time the best spa hotel on the Continent. It was warm out, a bit sticky even, as they waited for the kitchen to prepare an opulent supper. At a rather large and empty table the two of them talked, a woman and a man; a few others were nearby, out of earshot behind a bubbling fountain.

"The Hotel and its grounds were grand but restrained, and it was located, rather inconveniently, across the border from its best clients in an area known as Batavia. That was the name of the Netherlands around 1800, and the Dutch near the border of Germany persisted in calling their part of the country by the old name, even a hundred years after 'Batavia' had disappeared from maps. The Hotel had wonderful gardens, filled with hedges, rose trestles, fountains, and sculptures. There was a small casino, a ballroom, and even an indoor shooting range."

He glanced down the bar to see if they were still listening. A few stared at him—somewhat quizzically, he thought—and one or two looked into their beer as if lost in the play of color, light, and foam. For a moment he wondered what this bar had been, almost a century ago.

"They were sitting in what was pompously called 'The Park'—really just a paved terrace below the main level of the Hotel, decorated with a few white cloth-covered tables and red hanging Chinese lanterns. Mrs. Hortense Pline was a widowed heiress, though not particularly well off—she suffered from the so-called poverty of the landed gentry. She owned a Schloss, a big manor house in Valparaíso with some farmland, but usually she was on the road, lounging in various spas and retreats around Europe. And Mr. Hartung. He was a decent and respectable architect from Germany but had this quirk: he only accepted jobs from

clients who would allow him to build glass houses. Typically his designs were inspired by the original Crystal Palace, but by 1909, being a fashionable man he was intent on working with the new types of glass blocks and roof tiles that obsessed his contemporaries.

"All the surviving accounts agree that it started out with Pline complaining about life in a spa, her boring days of leisure. But that particular day she had a moment of poetic inspiration. Her usual complaints about the routine of reading, dressing, and dining were followed by a kind of soliloquy on a rather bizarre notion—a 'sickness for light.' If you read Hartung's memoirs, you'll find that he attempted to reconstruct their exchange from that evening as precisely as possible. I myself am paraphrasing from memory—it's been a while since I read his book—but according to him she went on something like this:

Oh Mr. Hartung, there is so little light during the night! During the day I feel oppressed by the coming evening; it makes me almost melancholy. At night I feel abandoned in the darkness! I am not demeaning the Hotel's grand lamps, but when I walk in the Park at night, as you know I often do after dinner, the lack of illumination is overwhelming. I suffer immensely from its departure, the transience of light; the stars and moon are insufficient, so distant. I must suffer from an addiction to light, to the sun of course, but also to that warm glow of electrical brightness. This must be the most modern of diseases: the suffering and longing each evening for the clear and sharp light of the electric arc. We live in an age of industry—light should be never ending!

"Well, the architect made fun of the heiress's complaint. He called his client punning names and told her she was acting like a strange visionary director of a new electrical utility. But Pline persisted in thinking her problem was quite reasonable, so he changed tact and tried to explain how the world absorbs the energy of light, that electricity could never match the brightness of the day. This did little to quell her imagination. Hartung, at the end of his rope, declared: 'I can only suggest, dear Madame, that you illuminate an unused cavern of a mine shaft and move in there permanently.' To his astonishment her response to this was, Yes! What a perfect suggestion! She'd do it!"

Well into his second whiskey, the storyteller grinned. "Hartung was incredulous. In his memoirs, he details his reaction in a very patronizing and sexist manner." His voice deepened slightly as he recounted another passage from Hartung's journal.

I felt I was in the presence of some sort of deluded female engineer. Her ranting suggested the image of huge electrical lamps lighting the night sky, but I explained to her that no amount of electrical energy, no matter how widely it was distributed, could ever fill the night sky and displace the darkness. She seems to understand nothing of physics, and this certainly got me into trouble tonight. When I described the nature of particles she had the audacity to claim I was a coward, fearing the new! She even declared that the progress of the world would stop without the courage of women!

"After Hartung suggested the idea of the mine, Pline clapped her hands together, calling to their table a few hotel guests who

were nearby. The group that gathered was more or less random: a British painter and good friend of Pline's, Arabelle Thackeray, and two American gentlemen, young and rich, on a Grand Tour of Europe who were taking, you might say, a 'pause' in their travels. Apparently they preferred the comforts of a spa hotel to traipsing through grottoes, and besides, where else would they meet some respectable young women, or the odd heiress . . .

"Pline raised a glass of champagne and addressed the group with a speech that so struck Hartung, he claims he recorded it verbatim. I'll see if I can remember it as well."

The storyteller's voice took on a new quality, as if he was now imagining himself as Pline—filled with a new, exciting vision but surrounded by skeptics.

We are a modern people—different from all those before us! We cannot suffer the same fate of people who toiled in darkness, of any kind. You see, electricity is no mere technology but an example of our new Enlightenment. Perhaps you think me drunk, but when I explain it in full you will immediately recognize yourself in what I am saying.

We are all addicted: we hunger for light, for understanding, and a new certainty. Our addiction is not based on the superstitions of the past, be they worship of another world or nature itself. As modern people with our most modern disease—the light-hunger—we should conquer this world, fill it with a kind of brightness. Those who study astronomy claim there is incredible energy in the sun and the stars even though they are far away and dim (at least to me).

Astronomers claim an immensity beyond our un-

derstanding. I do not want to compete with these great thinkers, but to simply declare that they are timid. They are men and men are timid in all ways, including—most importantly—in imagination! For it is but a matter of time before our dear Tesla—now he is in America—discovers the ultimate power of illumination: energy infinitely dispersed across our globe, chasing all shadows from every dusty corner.

"Hartung interjected that if she was going to talk about action, she would be best served by stating the matter directly. He wrote that he told her no less—even admitting to addressing her presumptuously, in his frustration, by her first name, Hortense—and that she should get to the point. Pline continued, rather courageously, I'd say:

Tonight I officially announce the formation of a Light Club, the Light Club of Batavia. A spa to exceed all spas, a place for limitless intellectual insight and discovery, a model for the world! I declare this spa will be built within the year—one year from today, July the 1st, 1909—but it must be private and secluded otherwise its effects will be too disruptive to the normal order of things. We must wait until the new discoveries are firmly in place before we can implement our plans everywhere. And in accordance with Mr. Hartung's opinions—even if they are perhaps misguided—that we are not yet advanced enough to form such an institution out of doors, I will build my spa at the base of an unused mine nearby to us, the abandoned mine that we've all heard about from the servants. At the confluence of the passageways and shafts is a huge room

that is highly suitable. The world will see what women achieve with our determination and brave imaginations! If any one of you disbelieves or disavows my resolve, I set against this—my declaration—my Manor Hall and all the grounds at Valparaíso. Some of you have been there, but many can attest to its worth.

At this point, no one listening could have been completely sure of anything, neither how much this voluble man at the end of the bar had had to drink, nor how the saga would end. Another swig of whiskey made his voice husky.

"Hartung recounts the reaction to Pline's proposal in a disdainful tone. How the 'youthful Americans' exclaimed how 'exotic' it was. How they tried to out do one another in pledging funds for the project. But our lady was unimpressed with their offers and outlined their insufficiency in no uncertain terms:

Thank you for your belief and what I hope will be at least some modicum of support for the installation of our world of light! I must tell you though, about the scale . . . men always think so small. There will be at least two hotels and ten private villas, even an electric tram. Everything will be built with the new types of glass and a hidden steel infrastructure. Only materials that are the most aesthetically and technically advanced will do! And the new colors that are sweeping across the continent— the spa must have the most harmonious arrangement of this aesthetic progress. Ten-meter-wide hanging lamps will illuminate the bathing areas. Pillars of glass, columns of light will support the ceiling, connect the walls, and extend in every conceivable direction! Glass, colored

glass! All of it will conform to the ideal of the enlighten-
ment that light itself brings!

"You can see," commented the narrator, his speech slurring
from all he had imbibed, "how the architect thought of women
and how this woman thought of herself. You might even think of
these events as some kind of harbinger of the future—but don't
draw any conclusions yet…I digress. You'll see what it all means
when I get to the end of this neglected—but important—piece
of history…"

He left off—his head seemed to drop—but then immediately
jumped back into the flow, into character one might say, as he
again tried to imitate a female voice—the heiress.

If I achieve my aims within the time I have given
myself, you each must promise me something in return—
something to compensate for your lack of total faith in
real vision. Your grudging agreement to my wager—yes
I see it in your faces. You must agree to a consequential
act yourself—not some act of charity and no, nothing to
do with the spa itself—but an act of vision I myself will
invent for you. I promise whatever I request will be in
complete concordance with the values we are creating
underground. I predict that in the end our ethics will
spread across the surface of the globe!

"Hartung was flabbergasted by what happened next. The two
Americans, Mr. Krumhübel and Mr. Benjamin, wholly agreed to
all of it, with the caveat that under no circumstances would either
of them commit murder on behalf of the heiress. But moreover,
Mr. Benjamin offered to fulfill any wish Pline might have if the

establishment of the light spa failed, and in an obvious—and, to Hartung, unsavory—act of flirtation, Mr. Benjamin extended this to Arabelle Thackeray as well, the young painter who was clearly unattached. In Mr. Hartung's view, all of this displayed a typically American propensity for brutality and a lack of communitarian values or societal niceties. But the heiress, not viewing the Americans with the same jaundiced eye, simply accepted their terms.

"Then, apparently to the architect's chagrin, Pline nominated Hartung to be the engineering and building consultant and also the lawyer and secretary of the organization. She asked that he immediately codify everything they had discussed in writing before anyone had second thoughts. He tried to extract himself from the arrangement by informing her that under the German Civil Code all contracts that mention criminality, like murder—though strangely enough, he used the word 'morality'—were null and void."

The storyteller, eyes sparkling, tipped his head back and drained his glass. "I laughed out loud when I first read what happened next. The heiress reminded poor Hartung that, unfortunately for him, the future spa and Batavia itself were not yet within the German Empire . . . A perfect example of the convergence of utopia and imperial ambition, no?"

Blearily he scanned the blank faces around him. His head was swimming as, undaunted, he closed his eyes and continued his tale.

"The artist, the woman from England, was not wealthy herself so she hadn't offered money toward the light spa's construction, so it seems she felt it necessary to limit her exposure in this high stakes bet, especially in light of Mr. Benjamin's suspicious generosity. The one promise she made that night was to sculpt

a portrait bust of Mr. Benjamin out of the new colored glass, if her friend failed to achieve everything they had planned."

Someone cleared their throat, and the narrator caught some weary glances. "OK, I'll cut to the chase. A year later the heiress was completely bankrupt but there it was: a mine with the light spa at the bottom of it, just as she envisioned it. The site of the spa was not marked in a way that might reveal its purpose, other than some tidy glass and brick warehouses that cloaked huge new turbines. Some of the turbines were driven by waterfalls but most of them relied on kerosene or coal to generate the massive amounts of electricity needed by the spa, with all its bathing lamps, elevators, and electric trams.

"By then it was the summer of 1910—an even hotter summer than the one preceding it—and the group gathered again in Batavia. Her counselor, Mr. Hartung, confirmed to the rest of the party that everything was complete and infinitely bright at the bottom of the mine. Mrs. Pline had a car waiting outside— what a luxury at that time—as she wanted the two bachelors to accompany her to the secret light spa immediately.

"The two so-called gentlemen wanted to know what they had to do to fulfill their lost wager. I think their ideas tended toward the lascivious, and they probably hoped the ladies shared their sentiments. But instead, both Pline and Thackeray declined to collect on the wager, and they wouldn't reveal what might have been their wishes. The men were disappointed, though they could hardly complain. But I bet they dallied a bit on their way to the waiting car—being men of their time, they were likely reluctant to acknowledge the success of the heiress's vision.

"The entrance to the mine was hidden like some ridiculous movie set for a Western, with broken boards crisscrossing the entrance. But one could catch a glimpse of the extreme moder-

nity it now enclosed. In the late afternoon sun, the glass and metal elevator sparkled in the darkness.

"They could see through the colored glass floor in the elevator, as they lowered into the depths, that the light got sharper, denser, ever more intense. When they stepped out, what struck everyone most—the architect included, who had seen it once already—was the utter silence. The light seemed to absorb sound, even space, into the material of illumination—swallowing words, footsteps, thought."

He paused yet again, but this time it was different. Everyone at the bar, even the bartender, was rapt and waiting for him to continue.

"The strangest part of the story was that in the end, they had forgotten the people—other than themselves—who would populate this strange, hallucinatory space. The papers that the architect had drawn up were premised on this small group alone knowing the location of the spa. As they wandered through the colored light, they realized how absurdly large it was for their use alone. They were like some strange colonists on a distant moon, there to repopulate a new world."

As if to respect their own spinning thoughts or perhaps to conjure the echoing emptiness of the light spa, everyone at the bar was silent for a long while, not even lifting their glasses. But they all noticed how dark it had suddenly become. The sun had disappeared behind the buildings to the west. The bartender had forgotten to turn on the lights and the dull blue hue of the street lamps gave their faces an unhealthy glow.

ÜBER SCHEERBART

von Georg Hecht

Um für flüchtige Leser, die es einmal mit Scheerbart versuchten und nie wieder, die Hauptsache gleich an den Anfang zu stellen, sei gesagt, daß Scheerbart zu den ganz großen Könnern in der literarischen Kunst Deutschlands gehört und in der ganzen Vergangenheit und Gegenwart dieser Kunst keinen hat, dem er irgendwie gliche. So ganz ist er, so einzigartig.

Natürlich findet ein genau vergleichender Blick Punkte und Linien dieser scheerbartischen Art z. B. bei Jean Paul, (oder bei Swift und Cervantes); aber diese wenigen Gleichheiten verschwinden vor der großen Andersartigkeit. Und so mag es sich erklären, daß Scheerbart noch heute wie in seinem Anfang umstritten ist. Vor nicht allzu langer Zeit erzählte ein Rezensent, daß er Zeuge oder Beteiligter eines erbitterten Streites gewesen wäre, in dem Scheerbart bald gelobt, bald verdammt worden sei. Der Rezensent entschuldigte so seine zwiespältige Meinung. Und es war nicht irgendwer. Bei einer anderen Gelegenheit konnte man erfahren, daß entschieden Verwahrung dagegen eingelegt wurde, wenn zwischen Scheerbart und – sagen wir: Nietzsche eine Parallele gezogen wurde.

Die Unvergleichlichkeit erklärt indessen nicht genau das Unverständnis, dem Scheerbart begegnet. Es liegt auch an der Sache selbst, deren Schwierigkeit eine doppelte ist, wenn es

einmal erlaubt ist, die Innigkeit von Scheerbarts Form und Inhalt analytisch aufzuheben.

Also die Form, der Stil – das ist die erste Schwierigkeit. Man liest ein Buch, und es kann geschehen, daß man nichts darin findet, als die reinste Virtuosität im Vermeiden alles dessen, was der Bürger den poetischen Stil nennt, der ihn erhebt und befriedigt. Hier aber ist die ganz gewöhnliche Sprache, hier sind die ganz gewöhnlichen Worte, keine schönen Bilder, kein Reichtum von seltenen Vergleichen. Es versteht sich von selbst, daß dieser scheerbartische Stil sehr viel Ruhe, sehr viel Andacht vom Leser verlangt, die Kunst des langsamen Lesens voraussetzt, wenn überhaupt gemerkt, gefühlt werden soll, daß die Sprache Scheerbarts nicht schlechthin die der Straße ist, sondern sich durchaus nicht und in keinem Punkte gehen läßt und eine plötzliche Treffsicherheit und Kürze hat, die sich kaum beschreiben ließe. Und was nun auch den aufmerksamen, langsamen Leser am Ende überraschen wird, ist, daß dieser Stil im gegebenen Fall Monumentalität haben kann und epische Breite. Schon in seinem ersten Buche, „Das Paradies, die Heimat der Kunst", da der Dichter zu Gott emporfliegt, zu dem Vater der Kunst, – dann in „Liwûna und Kaidôh" und weiter dann in allen Werken ist diese Monumentalität der einfachen Worte. Aber – und hier beginnt die zweite Schwierigkeit des scheerbartischen Gesamtwerkes – dieser Stil erschließt sich dem Laien kaum in einem Buch; es ist nötig, die Bücher der Reihe nach zu lesen. Dieser Dichter ist in einem Buch nicht zu fassen, das sei flüchtigen Lesern gesagt. Und wer nach dem einen Buch nicht die schöne Begierde empfindet, das zweite zu besitzen, hat seine Art nicht genau erfühlt, auch wenn er langsam und aufmerksam las; denn auch das Stoffliche ist schwierig.

In den Romanen aus dem Durchschnitt und darüber ist ja

viel von Geschehnissen die Rede, ja es gilt als was Besonderes, sie bis zur äußersten Gespanntheit zu verwickeln. Da meist von Liebe die Rede ist, ergeben sich die Kombinationen: ob zwei sich bekommen oder nicht, ob sie sich noch wollen, wenn sie sich schon hatten, was das Letzte in diesen Möglichkeiten ist. Wenn aber bei Scheerbart das Thema die Liebe ist, wie in dem Eisenbahnroman „Ich liebe Dich", so ist das Ganze einmal ein vernichtender Hohn auf alle Unterhaltungware der Literatur und ist ferner in seinen Einzelheiten und wieder im ganzen die gefühls- und denknotwendige, durchaus erlebte und in der Form künstlerisch angeschaute Fortführung der bloßen Geschlechtsliebe in kosmische Weiten. Wenn von der Erfindung eines Perpetuum mobile gehandelt wird, so wird die Erfindung zu der Entdeckung, daß die Erde das „Perpeh" ist und alle Folgerungen, die im voraus gezogen wurden, für den Fall daß das „Perpeh" geht, behalten ihre Gültigkeit, ihre große Bedeutung; denn es geht ja, die Erde ist doch ein Perpeh. Und es ist eine der lächerlichen Ungeheuerlichkeiten, Scheerbart die Absicht zuzuschreiben, ein mechanisches Perpeh zu erfinden, wie er es zeichnet und beschreibt und dann achselzuckend am Verstand des Dichters zu zweifeln.

Dies ist so lächerlich, weil Scheerbart in der ganzen literarischen Kunst Deutschlands die fast einzige schöpferische Intelligenz ist. Das will sagen, daß er sich seiner Kräfte und Möglichkeiten bewußt ist, bis in das Innerste hinein, und alles vergessen kann, wenn er am Werke ist.

Das besagt, daß hier neben der Kunst der Betrachtung und des Gefühls die der Erfindung tritt, die wahrste, echteste.

Denn sein intelligentes, sehr gezüchtetes Können, wirkt, wenn er in seiner Kunst das Leben nicht begleitet, sondern es ausweitet und ihm zu neuen Formbildungen vorangeht.

Man hat von seinem Humor gesprochen, aber das ist ein Wort, das gar nichts erklärt. Man könnte auf Wilhelm Raabe hinweisen und die Parallele ziehen. Aber wenn die Kenner Raabes beisammen sind und sein Werk besprechen, gibt es kein Ende; wenn Kenner Scheerbarts beisammen sind, erhebt sich zwischen ihnen, dieweil sie zu reden beginnen, das große gemeinsame Schweigen.

ABOUT SCHEERBART

by Georg Hecht

Translated from the German by Barbara Schroeder

To begin with, it is important to state to the casual reader, who has attempted Scheerbart only once and then never again, that Scheerbart is one of the greatest artistic talents in German literature. There is no one, past or present, in any way like him, so total is he, so unique.

Of course an exacting, comparative eye will find points and lines of the Scheerbartian kind, for example, in Jean Paul (or in Swift and Cervantes), but these few similarities disappear in light of his work's very different nature. And thus it is understandable why today Scheerbart is still as controversial as he has always been. Not too long ago, a reviewer recounted that he witnessed or participated in a bitter argument in which Scheerbart was in one moment praised and in the next condemned. This is how the reviewer apologized for his own conflicting opinion. And he was not just anybody. On other occasions, one heard that protests were lodged when a parallel was drawn between Scheerbart and, say, Nietzsche.

Nevertheless, his peerlessness does not fully explain the lack of understanding Scheerbart faces. It is also due to the subject matter itself whose difficulty is two-fold, if for once it is permissible to break apart and analyze the intimate connection between Scheerbart's form and content.

So the form, the style—this is the first difficulty. One reads a book and it is possible that one finds nothing in it but the purest virtuosity in its avoidance of everything the bourgeois calls poetic style, which elevates and pleases. Here is very ordinary language, here are very common words, no beautiful images, no wealth of unusual comparisons. It goes without saying that Scheerbart's style requires a state of calm in the reader and great devotion. It requires the art of slow reading if its potential is to be realized—in order to sense that his language is clearly not that of the street. Without a doubt, it never loses control at any point, and its unexpected precision and economy can hardly be described. And what will also surprise the attentive, slow reader is that this style can be monumental and epic in its breadth. Already in his first book, *Das Paradies: die Heimat der Kunst* (*Paradise: The Home of Art*), in which the author ascends to God, to the Father of Art—then in *Liwûna und Kaidôh* and furthermore in all his works—there is this same monumentality of simple words. But, and this is the second difficulty with Scheerbart's oeuvre, his style does not reveal itself to the layperson in just one book. One must read the books one after the other. The author cannot be fully understood in only one book, the hasty reader should be told. And those who do not feel the pleasant desire after one book to own a second have not fully perceived its fine nature—even if one has read slowly and attentively—because the subject matter is also difficult.

In average novels and even those above average, there is much talk of events; indeed, it is considered something special to create tension by entangling these events as much as possible. Since most of this talk is about love, combinations occur:

whether two people find each other or not, whether they still want each other once they have had one another, and which among all of these is the final outcome. But when love is the subject for Scheerbart, as in his railway novel *Ich liebe Dich* (*I Love You*), the whole thing becomes a devastating mockery of literature as entertainment. At the same time it is, in detail and as a whole, a truly experienced and (in terms of its form) artistically envisioned transmutation of mere sexual love into a cosmic vastness, which is necessary both intellectually and emotionally. When he writes about the invention of perpetual motion, the invention becomes the discovery of how the Earth itself is "perpetual." Conclusions drawn in advance supposing that perpetual motion could exist therefore retain their validity, their profound meaning, because the Earth certainly is a functioning "perpetual" after all. It is a ridiculous outrage to ascribe to Scheerbart the intention of merely inventing mechanical perpetual motion, and then to doubt the poet's sanity with a shrug.

All of this is utterly ridiculous because Scheerbart is virtually the only creative intelligence in the German literary arts. That is to say, he is acutely aware of both his strengths and possibilities, to his innermost being, and can forget everything when he is at work.

This means that in his work, the art of observation and emotion are joined by the art of invention, the truest, most genuine of arts.

Scheerbart's intelligent, highly cultured ability is most effective when his art is not simply in concert with life but instead expands it and leads toward new formations. Many have talked about his humor, but such a word cannot explain anything. One could perhaps allude to Wilhelm Raabe and

draw a parallel. But when Raabe experts are together and discuss his work, there is no end to it. When Scheerbart experts gather together and begin to talk, something arises among them—a large collective silence.

ON SCHEERBART

An Essay by Branden W. Joseph

Toward the end of his life, Walter Benjamin completed a short text entitled "On Scheerbart," a mere remnant of a much larger project intended to explicate what he saw as the sophisticated political critique nestled within Paul Scheerbart's eccentric prose. Like Karl Krauss and Paul Klee, Scheerbart was someone whom Benjamin described as a "destructive character." With cheerfulness, such figures, according to Benjamin, sought nothing less than the purifying deracination of language, art, and architecture in order to prepare modern individuals to outlive the utter devastation of "experience"—the integral passing of cultural knowledge between generations—eviscerated by, among other things, contemporary technologized warfare.

For Scheerbart, the impending cultural conflagration was World War I, which erupted on the eve of his death, and which left its sufferers as silent as Georg Hecht's gathering of Scheerbart scholars. For Benjamin, it was World War II, which saw the horrifying perfection of aerial warfare that had been forecast by Scheerbart in *Die Entwicklung des Luftmilitarismus und die Auflösung der europäischen Land-Heere, Festungen und Seeflotten* (*The Development of Aerial Militarism and the Demobilization of European Ground Forces, Fortresses, and Naval Fleets*) (1909). Gone with human experience would be humanism and with it

"creativity," to which the already outmoded individual clings as a sign of his (always his) inwardness. Scheerbart, despite an unbridled and fantastical inventiveness, evinced nothing of creativity in this sense, but rather a particular and "difficult" linguistic dryness that, as Hecht declared, "avoid[s] . . . everything the bourgeois calls poetic style, which elevates and pleases."

For creativity Scheerbart would at times substitute language's complete decontextualization, as in the phonopoetic "Kikakoku!" section of *Ich liebe Dich! Ein Eisenbahnroman* (*I Love You! A Railway Novel*) (1897) or the "Monologue of the Mad Mastadons" of *Immer mutig! Ein phantastischer Nilpferderoman* (*Always Courageous! A Fantastic Hippopotamus Novel*) (1902). Here one finds words utterly bereft of transmitted culture—purified and devastated words, arbitrarily and inorganically assembled—sloughing off all experiential "richness" and thereby able to speak the "poverty" of an era that would become ours.

Scheerbart's love of glass was at one with this destructive joy, for glass, as Benjamin would later famously maintain, is material "in which it is hard to leave traces"—traces, that is, of the human inwardness that Benjamin found deposited in the folds of the antimacassars of the bourgeoisie's lavishly furnished apartments. Following a common science fiction trope, Scheerbart's *Glasarchitektur* (*Glass Architecture*) (1914) recounts the gradual vitrification of the earth's entire surface. Starting with a modestly enlarged veranda, which breaks free from and then absorbs the main building, glass crystallizes throughout the garden and then covers oceans and mountain peaks until the totality of the globe, and with it the culture of its inhabitants, is completely altered. "One thing leads to another," writes Scheerbart, "and to stop the process is unthinkable."

Once initiated, the growth of glass architecture is irrevers-

ible and incessant, thereby coinciding with Scheerbart's other great passion: perpetual motion, the achievement of which he detailed in *Das Perpetuum mobile* (*The Perpetual Motion Machine*) (1910). Whether sincere effort or satiric commentary on an overly mechanistic social order, the lure of perpetual motion runs throughout Scheerbart's work. Indeed, the fantastic glass palaces he imagined, their light effects constantly changing in response to their environment, figure as nothing less than machines for perpetual perceptual movement. Such qualities continue in Scheerbart's fiction. His novel *Das graue Tuch und zehn Prozent Weiß* (*The Gray Cloth and Ten Percent White*) (1914), which recounts the perpetual honeymoon travels of the Swiss glass architect Edgar Krug and his bride, Clara Weber, concludes only once Clara's friend, the painter Käte Bandel, agrees to marry Edgar's patron, Herr Li-Tung, and the two begin their own round-the-world nuptial voyage. Thus, the narrative continues after the end of the book, the second leg of the journey ceasing only, one supposes, upon the initiation of a third, and so on *ad infinitum*. Moreover, Hecht informs us, reading Scheerbart must progress in a similar fashion: "[H]is style does not reveal itself to the layperson in just one book. One must read the books one after the other."

For Hecht, Scheerbart's interest in the *perpetuum mobile* was metaphoric, neatly distinguishable from any sincerity that would lead one to question his mental state. Scheerbart, however, harbored a more nuanced idea of the role of the absurd. For Scheerbart, those irrational concepts that arise in direct proportion to the waning of traditional experience prove to be nothing other than what Benjamin (immediately after referencing *Glass Architecture*) would term "images in the collective consciousness." "If ideas are to be productive," noted Scheer-

bart, "they must really be 'in the air'—in very many heads at the same time—even if in a distorted form." This realization arose in Scheerbart around 1893 when he noted affinities between his own notion of glass, theosophical beliefs in crystal power, and the mirror-lined walls of Aschinger beer halls. He would thus conclude, "I am convinced that every constructive idea will appear in many heads at the same time and quite irrationally; one should therefore not speak carelessly about the seemingly confused and crazy; it generally contains the germ of reason." Scheerbart, like Benjamin after him, glimpsed utopia hidden within even the most distorted manifestations of collective experience. The germ of utopian truth within unreason forms the dialectical counterpart to Scheerbart's "brick bacillus," a physical sign of the most dire (architectural) failings of the actually existing world.

Scheerbart's glass is inextricably connected to other materials, through either structural necessity (as in iron and reinforced concrete) or decorative affinity (the colored enamel, niello, and majolica that compliment glass's luminescent effects). Also inseparable from glass is water, not only for the latter's "intrinsic capacity to reflect" (which will lead to a new Venice of floating glass cathedrals), but also on account of the need to siphon every possible source of hydroelectric power for lights to outshine day during nighttime. Equally inseparable from glass is the vacuum cleaner. Nonexistent fifty years before the publication of *Glass Architecture*, the vacuum was by then a ubiquitous presence in German households, nearly as important, according to Scheerbart, as running water. This fact demonstrated, in the most dramatic and most quotidian manner possible, the feasibility of astounding technological advancements. Once unforeseen, the vacuum cleaner was subsequently taken for

granted, as would be the glass architecture of the future. The only scandal, asserted Scheerbart, was that vacuums were not already used as insect exterminators in public parks.

The wonders of glass architecture are also indelibly linked to food. In novels like *The Gray Cloth*, Scheerbart describes food with a degree of specificity rivaled only by that of vitreous construction: "Swedish breakfast," "fresh common crabs," "artichokes," "roasted snails," "very good trout," not to mention the "piece of pike liver" held in Edgar's tongs as he proposes to Clara. Drink, too, is everywhere inventoried in detail: "soda water," "good burgundy," "fresh beer from . . . Brissago," and "German Rhine wine": "They drank hot grog and chartreuse, Benedictine and champagne. There was also beer—from Melbourne." Such descriptions are not the indulgences of a glutton, but rather the projections of a pauper (one who also dreamed of riches), for whom a very real poverty meant that food of any sort was not guaranteed. Food and glass architecture are alike in this way: both are utopian compensations for actual deprivations—of sustenance and taste, on the one hand, of light and air, on the other. Often living in destitute, slumlike conditions, Scheerbart's abhorrence of dark, musty, enclosed brick rooms was, as Reyner Banham put it, "an acquired hatred."

For Benjamin, Scheerbart's closest counterpart was Mickey Mouse. Like the asteroid-dwelling Pallasians of Scheerbart's *Lesabéndio: Ein Asteroïden-Roman* (*Lesabéndio: An Asteroid Novel*) (1913)—beings who were not *human* beings—Mickey Mouse functioned as a dream image to reveal to the inhabitants of Earth that they could survive outside of the human(ist) form that they currently assumed. Mickey Mouse thus joins the ranks of those joyfully destructive characters who help mankind prepare "to survive civilization."

Solely through the use of his body and the ordinary features of his environment (artificial and natural, from furniture to trees), Mickey Mouse is able to improvise, indeed to surpass and even mock, all sorts of technological feats without the use of technology. He thus prefigures a situation in which, according to Benjamin, "Nature and technology, primitiveness and comfort, have completely merged." Mickey Mouse is a harbinger of that moment when humankind, having shed or overcome that very designation, will have been able to achieve the perfectly resolved interplay with "nature" that is the goal of Benjamin's "second" technological age (which would culminate in the pilotless drone aircraft of today's wars). Furthermore, Benjamin foresaw that fostering subjective adaptation to this new second nature, in which technology infiltrates our lives to an unprecedented degree, would become art's paramount social function.

Such are the stakes of Scheerbart's writing. Scheerbart patiently details not only his world's technological remaking (through air travel and glass architecture), but also his characters' adaptation to it. Hence his ongoing discussion of the nervous effect produced by even the most desirable new technologies and the means for its alleviation. In *Glass Architecture*, it is the harshly innervating qualities of white light that must be replaced by the muted and calming effects of colored glass: "Not more light!—'more coloured light!' must be the watchword." In *The Gray Cloth*, direct sunlight shining through the walls of Edgar's glass Chicago pavilion renders viewers slack jawed until a passing cloud mutes their intensity. When Clara's organ begins to roar, listeners hurry "to the lower floors where the sound was less intense." Nor are Edgar and Clara fully habituated to the brave new world they help produce. After floating around the globe in Edgar's glass zeppelin, telegraphically communicating

with friends the world over, Clara declares, "Perpetual air travel has exhausted me greatly" and desires nothing more than to write a letter by hand. Shortly thereafter, Edgar admits his own need to mitigate the innervation of modern stimuli, including glass buildings. Although he declares himself capable of appreciating even a concert of gunshots and explosions, if he can attain a proper distance, it was the jarring chromatic effect of his own tinted glass that provoked him to insist that Clara always wear clothes made solely of grey cloth with a maximum of "ten percent" white detailing.

Despite accepting Edgar's sartorial stipulation, Clara, like nearly all of Scheerbart's female characters, is a "new woman." She smokes cigars and drinks "like an old salt"; her renown as a concert organist fully rivals Edgar's architectural fame; and she defies his imperiousness at every turn. Aided by several equally strong female characters—Käte Bandel, the sculptor Amanda Schmidt, and the Marquise Fi-Boh—Clara turns her honeymoon into a battle of the sexes, one that culminates with her emancipation from Edgar's imposition of the gray cloth dress code (to which she nonetheless ultimately reconciles). For Scheerbart, women's liberation is another factor leading to the overthrow of an outmoded humanist civilization predicated on *man*kind.

Featured as well in *Der Lichtklub von Batavia* (*The Light Club of Batavia*), the interaction of the sexes implicates desire. For Scheerbart, desire acts as the motor force behind adaptation to new technology. In *The Gray Cloth*, airborne travel through a new realm of glass, a world of constant transformation and transportation, is inextricably tied to the honeymoon. In *Liwûna und Kaidôh: Ein Seelenroman* (*Liwûna and Kaidôh: A Soul's Novel*) (1902), the fantastical, metamorphosing character Liwûna is eventually revealed to be nothing other than the manifesta-

tion of Kaidôh's own desire. In *The Light Club of Batavia*, the luminescent mine shaft is actually a wedding chapel.

For Scheerbart, both desire and the innervating effects of technology operate within the cycle of excitational increase and dissipation that Sigmund Freud theorized for the pulsions. Their eruption can resound throughout the whole environment:

> He kissed his wife politely on the hand.
> A thunderstorm started up, and they returned to the heated cabin.
> The sea roared violently.
> Herr Edgar commanded the airship to fly higher.
> And at an altitude of one thousand five hundred meters, the air was very still.

According to Hecht, Scheerbart's readers experience his characters' feelings via the effectiveness of his novels' artistic form. Scheerbart's writings thus reveal themselves as machines for innervation, facilitating readers' adaptation to the futuristic environments they foretell. They are also, evidently, desiring machines. For Hecht, "average novels" concern themselves primarily with various declensions of amorous encounters: "whether two people find each other or not, whether they still want each other once they have had one another, and which among all of these is the final outcome." But in Scheerbart's novels, which successfully transmute the machinations of "mere sexual love," there is no final outcome. There is only incessant transformation, a *perpetuum mobile* of technology, transportation, narrative, and desire that foretells a posthuman adaptation, our adaptation, to experiential poverty on a scale of "cosmic vastness."

Sources

Banham, Reyner. "The Glass Paradise." Architectural Review 125, no. 745 (Feb. 1959): 87–89.

Benjamin, Walter. "The Destructive Character" (1931), trans. Edmund Jephcott, in Selected Writings, vol. 2, 1927–1934, eds. Michael W. Jennings, Howard Eiland, and Gary Smith. Cambridge, MA: Harvard University Press, 1999, 541–42.

Benjamin, Walter. "Experience and Poverty" (1933), trans. Rodney Livingstone, in Selected Writings, vol. 2, 731–736.

Benjamin, Walter. "Karl Kraus" (1931), trans. Edmund Jephcott, in Selected Writings, vol. 2, 433–58.

Benjamin, Walter. "Mickey Mouse" (1931), trans. Rodney Livingstone, in Selected Writings, vol. 2, 545–46.

Benjamin, Walter. "On Scheerbart" (late 1930s or 1940), trans. Edmund Jephcott, in Selected Writings, vol. 4, 1938–1940, eds. Howard Eiland and Michael W. Jennings. Cambridge, MA: Harvard University Press, 2003, 386–88.

Benjamin, Walter. "Paris, the Capital of the Nineteenth Century" (1935), trans. Howard Eiland, in Selected Writings, vol. 3, 1935–1938, eds. Howard Eiland and Michael W. Jennings. Cambridge, MA: Harvard University Press, 2002, 32–49.

Benjamin, Walter. "Short Shadows (II)" (1933), trans. Rodney Livingstone, in Selected Writings, vol. 2, 699–702.

Benjamin, Walter. "The Work of Art in the Age of Its Technological Reproducibility: Second Version," in Selected Writings, vol. 3, 101–33.

Benjamin, Walter. "To Gerhard Scholem" (ca. 1 Dec. 1920), in The Correspondence of Walter Benjamin, eds. Gershom Scholem and Theodor W. Adorno. Chicago: University of Chicago Press, 1994, 167–69.

By Paul Scheerbart
Translations in English

Novels

Glass Architecture, trans. James Palmes, ed. Dennis Sharp. Compiled with Bruno Taut's *Alpine Architecture*, trans. Shirley Palmer. New York: Praeger, 1972.

The Gray Cloth: Paul Scheerbart's Novel on Glass Architecture, trans. John A. Stuart. Cambridge, MA: MIT Press, 2001.

Tales and Essays

"Cascading Comets," trans. Malcolm Green, in *Atlas Anthology*, no. 3 (1985), 110–12. Reprinted in *The Golden Bomb: Phantastic German Expressionist Stories*. Edinburgh: Polygon, 1993.

"The Cosmic Theatre," trans. Matthew Josephson, in *Broom*, vol. 4, no. 1 (Dec. 1922), 22–30.

The Development of Aerial Militarism and the Demobilization of European Ground Forces, Fortresses, and Naval Fleets: A Flyer by Paul Scheerbart, trans. M. Kasper. Lost Literature Series, no. 4. Brooklyn: Ugly Duckling Presse, 2007.

"The Stupid Ass: A Jupiter Drama," trans. Malcolm Green, in *Atlas Anthology*, no. 6, *Black Letters Unleashed* (1989), 61–62. Reprinted in *The Black Mirror and Other Stories: An Anthology of Science Fiction from Germany and Austria*, trans. Mike Mitchell, ed. Franz Rottensteiner. Middletown, CT: Wesleyan University Press, 2008.

In the Original German

Novels

Das graue Tuch und zehn Prozent Weiß: Ein Damenroman [The gray
 cloth and ten percent white: A ladies' novel]. Munich and Leipzig:
 Georg Müller, 1914. Reprint, with an afterword by Mechthild Rausch,
 Munich: edition text + kritik, 1986.

Das Paradies: Die Heimat der Kunst [Paradise: The home of art]. Berlin:
 Commissions-Verlag von George und Fiedler, 1889. Reprint, Berlin:
 Verlag deutscher Phantaster, 1893.

Das Perpetuum mobile: Die Geschichte einer Erfindung [The perpetual
 motion machine: The story of an invention]. Leipzig: Ernst Rowohlt,
 1910. Reprint, with illustrations by Dieter Roth, Erlangen: Klaus G.
 Renner, 1977. Reprint, with illustrations by Johannes Vennekamp,
 Munich and Salzburg: Klaus G. Renner, 1997.

Glasarchitektur [Glass architecture]. Berlin: Verlag Der Sturm, 1914.
 Reprint, with an afterword by Wolfgang Pehnt, Munich: Rogner und
 Bernhard, 1971. Reprint, with an afterword by Mechthild Rausch,
 Berlin: Gebr. Mann Verlag, 2000. Translated into Italian by Mario
 Fabbri and with an afterword by Giulio Schiavoni, Milan: Adelphi,
 1982.

Ich liebe Dich! Ein Eisenbahnroman mit 66 Intermezzos [I love you! A
 railroad novel with sixty-six intermezzos]. Berlin: Schuster und
 Loeffler, 1897. Reprint, edited and with an afterword by Matthias
 Schardt, Siegen: Affholderbach und Strohmann, 1987.

Immer mutig! Ein phantastischer Nilpferderoman [Always daring! A
 fantastic hippopotamus novel]. With book ornamentation by Paul
 Scheerbart. Minden: J. C. C. Bruns, 1902. Reprint, Frankfurt am
 Main: Suhrkamp Taschenbuch, 1990.

Lesabéndio: Ein Asteroïden-Roman [Lesabéndio: An asteroid novel].
 With illustrations by Alfred Kubin. Munich and Leipzig: Georg
 Müller, 1913. Reprint, with an afterword by Paul Raabe, Munich:
 Deutscher Taschenbuch Verlag, 1964. Reprint, with an afterword by
 Kai Pfankuch, Hofheim: Wolke, 1986. Reprint, Frankfurt am Main:
 Suhrkamp Taschenbuch, 1986. Translated into Italian by Piera di
 Segni and Fabrizio Desideri, Rome: Editori Riuniti, 1982.

Liwûna und Kaidôh: Ein Seelenroman [Liwûna and Kaidôh: A souls
 novel]. Leipzig: Inselverlag, 1902.

Essays

"Das neue Leben, architektonische Apokalypse" [The new life: An architectural apocalypse]. In Bruno Taut's *Die Stadtkrone*. Jena: Eugen Diederichs, 1919. Reprint, Berlin: Gebr. Mann Verlag, 2002, 9.

"Der Architektenkongreß" [The Congress of Architects]. In Bruno Taut's magazine *Frühlicht*, Herbst, 1921, 26.

"Der tote Palast, ein Architektentraum" [The dead palace: An architect's dream]. In Bruno Taut's *Die Stadtkrone*. Jena: Eugen Diederichs, 1919. Reprint, Berlin: Gebr. Mann Verlag, 2002, 135.

"Die Entwicklung des Luftmilitarismus und die Auflösung der europäischen Land-Heere, Festungen und Seeflotten: Eine Flugschrift" [The development of aerial militarism and the demobilization of European ground forces, fortresses, and naval fleets: A flyer]. Berlin: Oesterheld & Co., 1909.

"Die Reifen" [The mature ones]. In Bruno Taut's magazine *Frühlicht*, Herbst, 1921, 32.

By Other Writers

Banham, Reyner. "The Glass Paradise." *Architecture Review* 125, no. 745 (Feb. 1959), 87–89.

Benjamin, Walter. "On Scheerbart" (late 1930s or 1940s), trans. Edmund Jephcott, in *Selected Writings*, vol. 4, *1938–1940*, eds. Howard Eiland and Michael W. Jennings. Cambridge, MA: Harvard University Press, 2003, 386–388.

Bletter, Rosemarie Haag. "The Interpretation of the Glass Dream: Expressionist Architecture and the History of the Crystal Metaphor." *Journal of the Society of Architectural Historians* 40, no. 1 (1981).

Gropius, Walter. *The New Architecture and the Bauhaus*, trans. P. Morton Shand. Cambridge, MA: MIT Press, 1965.

Marchán Fiz, Simón. *La metáfora del cristal en las artes y en la arquitectura* [The crystal metaphor in art and architecture]. Madrid: Ediciones Siruela, 2008.

McElheny, Josiah. "Nowhere, Everywhere, Somewhere." *Cabinet* 30 (2008), 59–61.

Siegel, Josh. "The Alpine Cathedral and the City-Crown." *Projects 84: Josiah McElheny*. New York: Museum of Modern Art, online exhibition brochure, 2007.

Taut, Bruno. *Die Stadtkrone* [The City-Crown]. Berlin: Gebr. Mann Verlag, 2002.

Whyte, Iain Boyd, ed. *The Crystal Chain Letters: Architectural Fantasies by Bruno Taut and His Circle*. Cambridge, MA: MIT Press, 1985.

Whyte, Iain Boyd, ed. *Bruno Taut and the Architecture of Activism*. London: Cambridge University Press, 1982.

Zamyatin, Yevgeny. *We*, trans. Natasha Randall. New York: Modern Library, 2006.

Josiah McElheny is an artist who lives and works in New York. He has exhibited his work at national and international venues including the Museum of Modern Art, Orchard, and Andrea Rosen Gallery in New York, Donald Young Gallery in Chicago, Institut im Glaspavillon in Berlin, the Moderna Museet in Stockholm, White Cube in London, and the Museo Nacional Centro de Arte Reina Sofía in Madrid. He is currently a senior critic in sculpture at Yale University School of Art. He has written for *Artforum* and *Cabinet* among other publications and is a contributing editor to *BOMB*. Other published monographs and artist books include *Josiah McElheny: A Prism* (Rizzoli, 2010), *A Space for an Island Universe* (Turner and MNCARS, 2009), *Island Universe* (White Cube, 2008), *Notes for a Sculpture and a Film* (Wexner Center for the Arts, 2006), *The Metal Party* (Public Art Fund and Yerba Buena Center for the Arts, 2002), *Josiah McElheny* (Centro Galego de Arte Contemporánea, 2002), *Josiah McElheny* (Isabella Stewart Gardner Museum, 1999), and *An Historical Anecdote About Fashion* (Henry Art Gallery, 1999).

Josiah McElheny's performative reading project *Der Lichtklub von Batavia/The Light Club of Batavia* premiered in 2008 at Orchard in New York and Institut im Glaspavillon in Berlin. *Light Club*, a collaborative film with Jeff Preiss was screened

in conjunction with those performances and at Donald Young Gallery in Chicago in 2008. The sculpture *Model for a Film Set (The Light Spa at the Bottom of a Mine)* was also exhibited at Orchard and Donald Young Gallery.

Gregg Bordowitz is a filmmaker, writer, and author of *The AIDS Crisis Is Ridiculous and Other Writings, 1986–2003* (Cambridge, MA: MIT Press, 2006) and *Volition* (New York: Printed Matter, 2009).

Wilhelm Werthern is a translator based in Berlin who specializes in texts about art, culture, and the humanities.

Andrea Geyer is an artist from Germany who lives and works in New York. She has exhibited her work at Documenta 12 in Kassel, Germany, Generali Foundation in Vienna, Tate Modern in London, and elsewhere.

Georg Hecht was a German writer and critic born in 1885. He died as a fighter pilot on the Western Front in May of 1915.

Branden W. Joseph is Frank Gallipoli Professor of Modern and Contemporary Art at Columbia University and a founding editor of the journal *Grey Room*. He is author of the books *Random Order* (Cambridge, MA: MIT Press, 2003) and *Beyond the Dream Syndicate* (New York: Zone Books, 2008).

Ulrike Müller is an artist and coeditor of the queer feminist journal *LTTR*. She has exhibited her work at the New Museum of Contemporary Art in New York and the Carpenter Center in Boston among other venues.

Paul Scheerbart was a German writer born in 1863. His essays and stories on architecture and glass were influential to his contemporaries and his best-known work *Glasarchitektur* was written a year before he died in 1915.

Barbara Schroeder is a New York–based art historian and editor at Dia Art Foundation.

ACKNOWLEDGMENTS

I would like to thank everyone at the University of Chicago Press, Orchard gallery in New York, and Institut im Glaspavillon in Berlin for their generous, thoughtful participation and insight.

This book was edited by myself, Susan Bielstein, and Rhonda Smith. It was designed by Michael Brehm. Erin Shirreff, Frank Heath, and Meg Clixby provided crucial editorial and design assistance as this project developed, from the original artist's book to this expanded volume.

I would also like to express my gratitude for the efforts of my collaborators in this book and for the general support and encouragement of Martin Beck, Christine Mehring, Michelle Kuo, Jeff Preiss, Jason Simon, Dave Hickey, Susan Bielstein, Iris Müller-Westermann, Donald Young Gallery in Chicago, Andrea Rosen Gallery in New York, and Susanne DesRoches.